ANATOMY
for the ARTIST

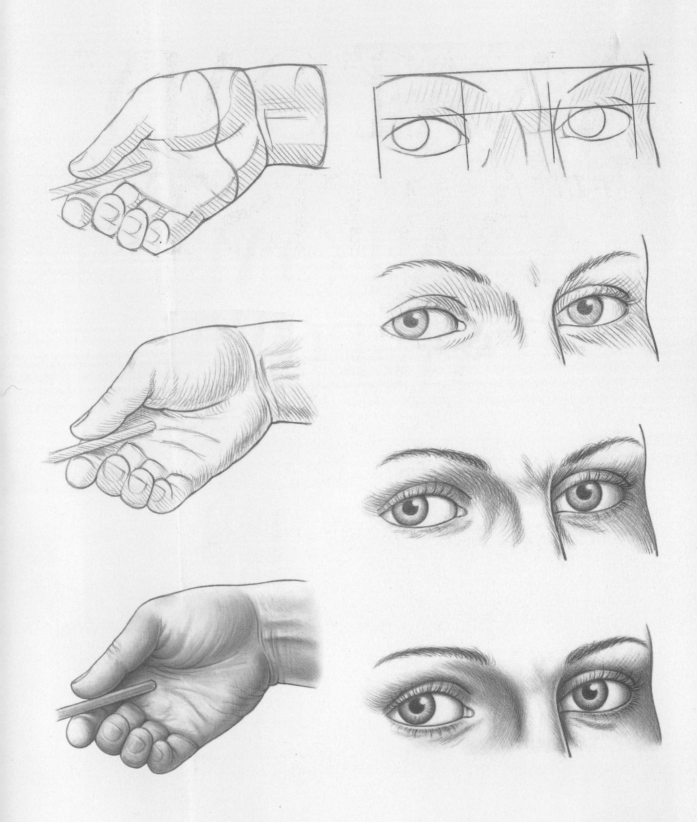

ANATOMY
for the ARTIST

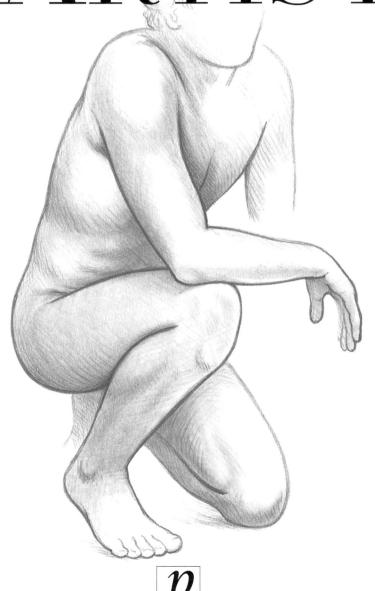

p

Created and produced for Parragon by
the bridgewater book company limited

creative director Stephen Knowlden
art director Lisa McCormick
editorial director Fiona Biggs
editor Sarah Yelling
designer Terry Hirst
photography Mike Hemsley at Walter Gardiner
illustrations Michael Courtney

ISBN: 0-75258-668-8

Printed in Dubai

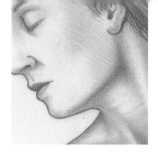

CONTENTS

INTRODUCTION 6
Drawing techniques and equipment • Sketches and tips • The skeleton
Muscles: an overview • Muscles in action • Body types

THE HEAD AND NECK 22
The skull and face • The eye • The nose • Mouth and lips • The ear
The mandible • The movement of the jaw • The neck
Drawing the head and face • Different types of faces

THE TRUNK 46
The skeleton of the trunk • The trunk • The spine
The upper back • The thorax • The back • The shoulder
The shoulder girdle • The pectoral region • The abdomen
The male torso • The female torso

THE UPPER EXTREMITY 80
The arm • The scapula (shoulder blade) • The humerus
The radius • The ulna • The lower arm • The hand
How to draw hands • How to draw arms

THE LOWER EXTREMITY 114
The legs • The pelvis • The legs • The feet
The knee • The thigh • The knee • The lower leg
Drawing the feet • Drawing the legs

MOVEMENT 144
The upper body • The lower body • The figure

INDEX 158

INTRODUCTION

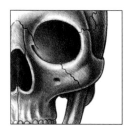 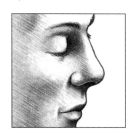 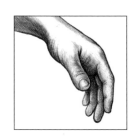 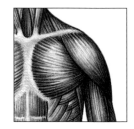

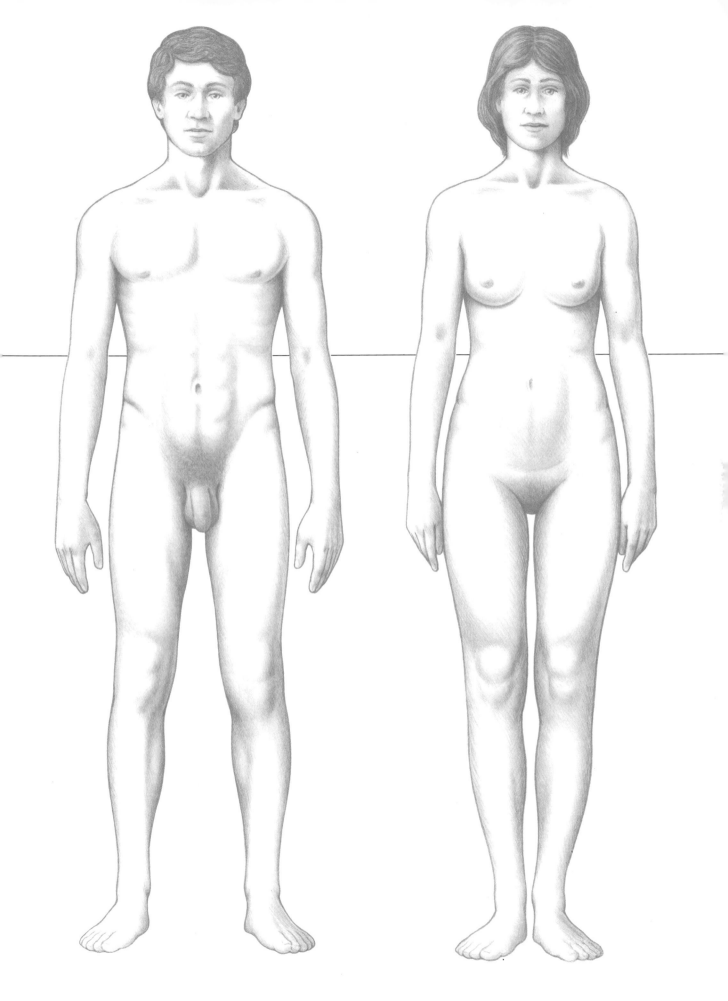

Introduction

In order to achieve lifelike illustration and to elaborate on the unique characteristics of each individual body, it is essential for artists to study human anatomy. Artists throughout the ages—from Michelangelo to Leonardo da Vinci, and Titian to Albrecht Dürer—studied anatomy because they realized that in order to understand the proportions and movements of the human body completely, they had to understand what went on underneath, namely the skeleton, the joints, and the muscles. This awareness of the body's structure enhances the artist's perceptions and improves the eye for form and detail.

Male thighs and buttocks

Bones

Together with teeth, bones form the most solid structure of the body. Actual bone tissue is composed of bone cells and intercellular substances. Around 30 per cent of this elastic connective tissue exists as collagens, while the rest of it is a hard anorganic substance, composed of calcium phosphate, calcium carbonate, and magnesium phosphate. Some of the bones possess a hard outer layer, which is called a cortex, and have an internal structure made of a spongy substance that contains bone marrow. There are various kinds of bone marrow. Cartilage is a firm but extremely elastic tissue; the most important cartilage is found at the end of the ribs and the joint surfaces of the arm and leg bones. Bone membrane covers the bones and contains nerves and blood vessels, through which the bone derives its nutrients. Joints are the flexible connections between two or more bones. Their surfaces are covered with cartilage and they are easily mobile.

Male torso

Female back and torso

Muscles

Muscles are needed in order to move—they are organs in their own right that receive impulses and contract in response to stimuli. They also form a major part of the total body mass. For example, about 200 to 250 muscles will normally account for 36 to 45 per cent of body mass. Muscles are frequently located in facing pairs; when one muscle flexes the elbow then another will extend it. However, muscles do not only have this role of movement. They also play a part in the position and stability of the joints, they carry the weight of an organism, and protect its internal organs. Muscles work together to maintain the body's balance and also its form, size, and contours. When we look under a microscope at conscious muscles—those that can be deliberately controlled—we see that they are composed of horizontally striated muscle fibers.

Female thighs and buttocks

Crouching male

Drawing tips

- You may find that you have a tendency to work small, even on a large sheet of paper. In an art class, for example, you are encouraged to work on a large scale with soft materials to promote fluidity of line.

- Start by doing quick sketches in order to loosen up your hand and to help you to concentrate on the essential lines in a figure.

- Change position regularly so that you can find an interesting feature that you can use as a focal point. This stops you from getting stale.

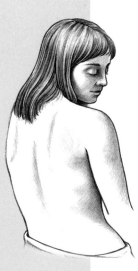

Back view of turning female

10

Drawing techniques and equipment

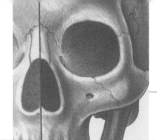

Equipment

The following basic equipment is vital for the artist. Buy the most expensive pencils that you can afford.

PENCILS
1 Graphite pencils
2 Watercolor pencils
3 Charcoal pencil and sticks

CRAFT KNIVES
4 Scalpel
5 Mat knife

FIXATIVE
6 Fixative for pencil and charcoal

ERASERS
7 Putty eraser
8 Art eraser

SHARPENERS
9 Pencil sharpener

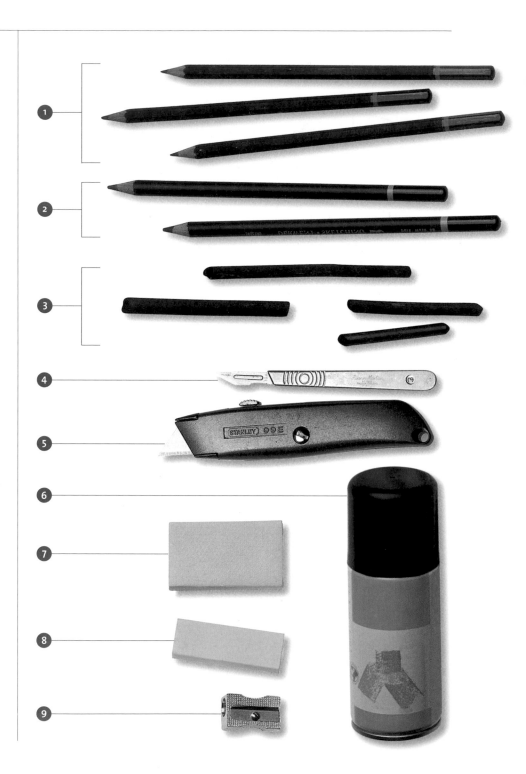

Drawing techniques

SCHOELLERSHAMMER PAPER

a

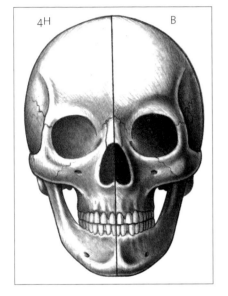

4H B

WATERCOLOR PAPER

b

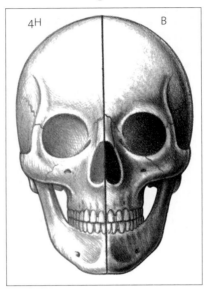

4H B

CARTRIDGE PAPER

c

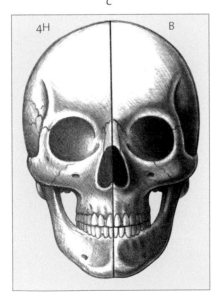

4H B

The results of using the same pencils (graphite) on different kinds of paper.

Compare the darkest tones on paper (a) with those on papers (b) and (c). There is more tonal range on paper (a) than on papers (b) and (c).

All the drawings in this book were done on 6G Schoellershammer paper using Derwent Graphic pencils, grades B to 4H. The highlights were achieved using a putty eraser molded to a fine point, and the tones were smoothed with a torchon. Normally, you would not be working on such smooth paper, but this was used because it is ideal when reproduction has to be considered.

Try experimenting with different surfaces of paper, using pencil, crayon, or charcoal to see how various effects can be achieved. Hold the pencil or charcoal stick almost flat on the surface and then in the normal writing position.

When you draw, you are making statements on paper that convey information to the viewer concerning the shape, form, and texture of objects; in this case, figures.

The first few lines that you draw on the paper are likely to be the most difficult, especially when you are a beginner. Don't be afraid to make mistakes because you can always strengthen the lines later when you are sure that these are correct.

Sketches and tips

Types of lines

These are just a few examples of the many kinds of lines that are possible, the characteristics of which will vary according to the materials used.

a These unvaried lines were drawn with a 4H pencil and might be used if you wanted an accurate outline to form the basis of a small painting, for example.

b Simple varied lines can be drawn with a softer pencil, and convey a better feeling of form and contour, because they are more expressive.

c You are more likely to use tactile lines in figure drawing, and these would probably be much freer and looser than those shown in this small example. Plane changes can also be indicated by using more angular strokes.

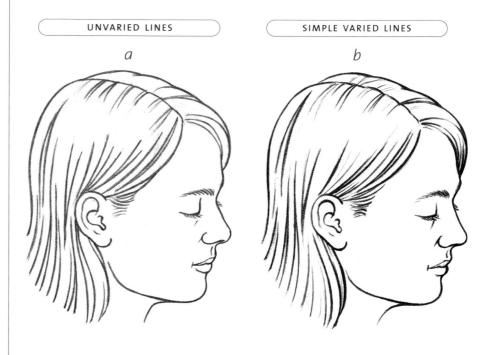

UNVARIED LINES

a

SIMPLE VARIED LINES

b

TACTILE LINES

c

13

Planes, light, and contour

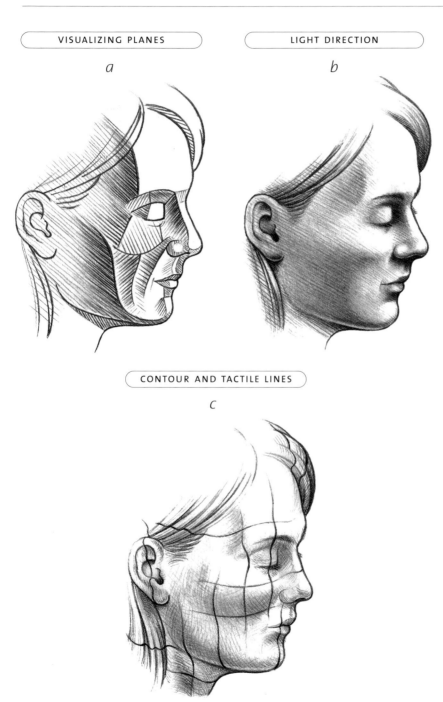

VISUALIZING PLANES

a

LIGHT DIRECTION

b

CONTOUR AND TACTILE LINES

c

You should always be aware of plane changes, lighting, and contours that affect the human form, so that you can render these correctly. It is a good idea to put an arrow on the side of the paper to indicate the direction of light. Establishing the areas of darkest tone will help to determine the tones in the rest of the drawing.

a Visualizing the planes and surfaces of the figure.

b Deciding on the direction of the light and the main areas of light and shade. (Reflected light will give a better indication of form.)

c Appreciating contour lines and using tactile lines and hatching when developing form.

14

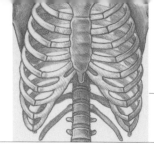

The skeleton

Ventral view

The skeleton supports the body, protects the internal organs, and provides a framework of muscles to work against, permitting movement. The bones of the head, neck, and trunk are referred to as the axial skeleton. Radiating out from the axial skeleton are the bones of the upper and lower extremities, which form the appendicular skeleton.

KEY TO THE SKELETON: VENTRAL

1 Skull
2 Cervical vertebrae
3 Clavicle
4 Scapula
5 Sternum
6 Humerus
7 Rib cage
8 Lumbar vertebrae
9 Radius
10 Ulna
11 Pelvis
12 Sacrum
13 Carpals
14 Metacarpals
15 Phalanges
16 Femur
17 Patella
18 Tibia
19 Fibula
20 Tarsals
21 Metatarsals
22 Phalanges

SKELETON: VENTRAL

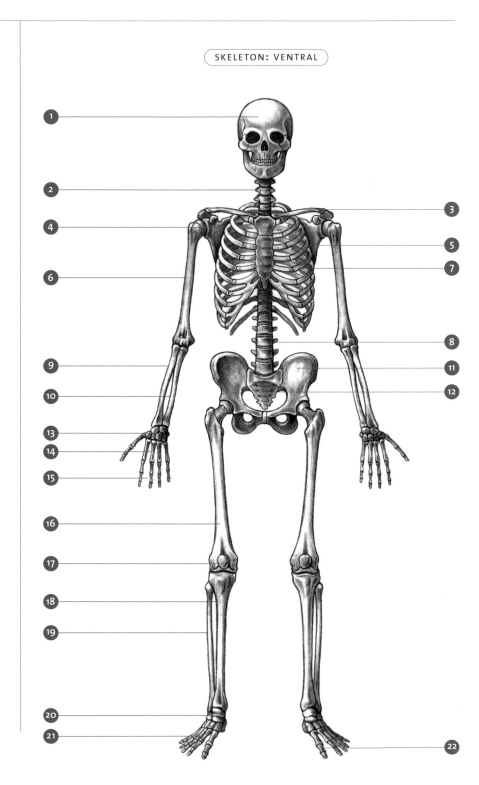

Lateral and dorsal view

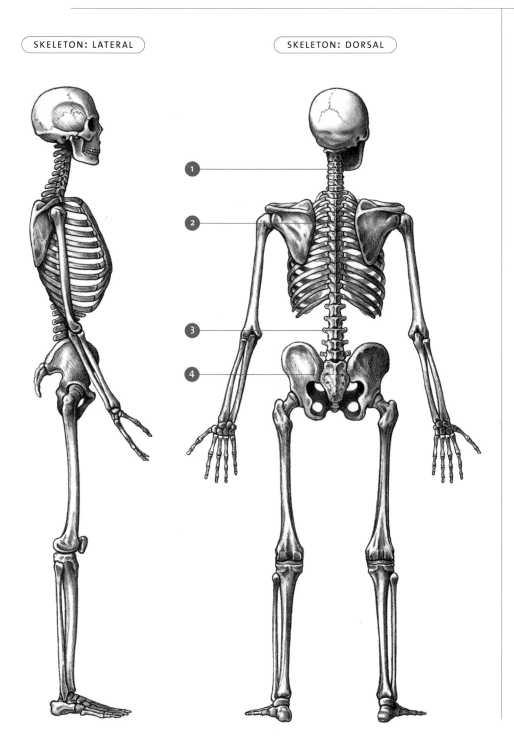

SKELETON: LATERAL

SKELETON: DORSAL

The graceful curvatures of the spine help it to support the weight of the upper body. Vertebrae are classified according to the level of the body at which they occur: cervical vertebrae are located in the neck, while the thoracic and lumber vertebrae are found farther down the spine. The sacrum lies at the base of the spine and forms part of the pelvis, connecting the lower extremities to the axial skeleton.

KEY TO THE SKELETON: DORSAL
1 Cervical vertebrae
2 Thoracic vertebrae
3 Lumbar vertebrae
4 Sacrum

16

Muscles: an overview

The main muscles

Muscles are formed of organized bundles of fibers that contract in a coordinated manner in order to produce movement. In general, muscles consist of an upper portion (the head), a bulky central region (the belly), and a tendon (a tough strip of tissue that connects the muscle to the structure that it moves).

KEY TO THE MAIN MUSCLES
1 Frontalis
2 Orbicularis oculi
3 Orbicularis oris
4 Sternocleidomastoid
5 Trapezius
6 Deltoid
7 Pectoralis
8 Biceps
9 Rectus sheath
10 Rectus abdominis
11 Tensor fasciae latae
12 Rectus femoris
13 Sartorius
14 Vastus medialis
15 Patella
16 Tibialis anterior
17 Peroneus longus
18 Gastrocnemius
19 Tibia (bone)
20 Extensor digitorum longus
21 Soleus

KEY TO MUSCLE STRUCTURE
1 Head
2 Belly
3 Bundle of muscle fibres
4 Tendon

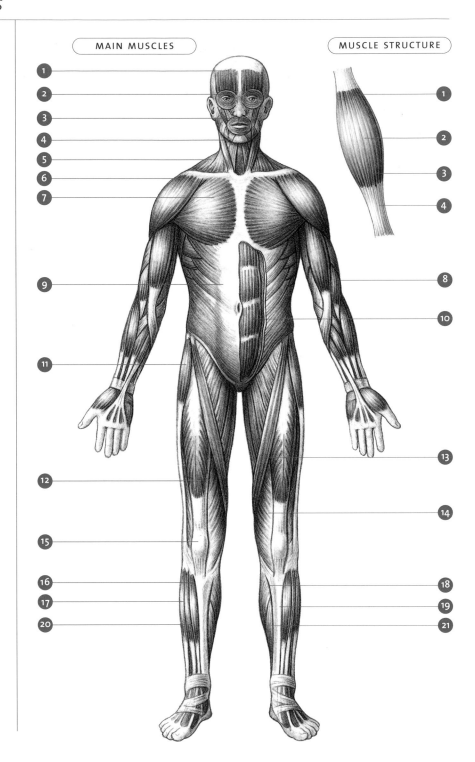

MAIN MUSCLES

MUSCLE STRUCTURE

The different types of muscles

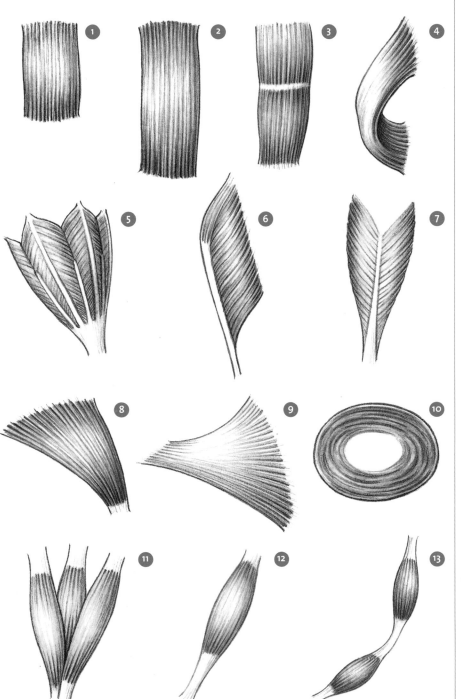

Muscles occur in a variety of shapes in order to suit their function within the body. In particular, muscles may be strap like, fan-shaped, or spindle-shaped (fusiform).

1 Quadrilateral
2 Strap
3 Strap with tendinous intersections
4 Spiral strap
5 Multipennate
6 Unipennate
7 Bipennate
8 Triangular
9 Spiral triangular
10 Circular
11 Tricipital
12 Fusiform
13 Biventer

MUSCLE SHAPE LOCATIONS

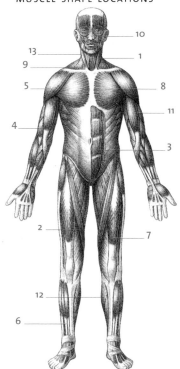

The shoulder muscles: agonistic action

Movement occurs when muscles work together as a group: muscles known as agonists create the movement, while other muscles participate by stabilizing adjacent bones and joints, even though they do not directly contribute to the movement itself. Meanwhile, muscles that might otherwise pull in the opposite direction automatically relax, so that the movement can take place unhindered.

a **LOCATOR**
Back view of shoulder and arm

b **KEY TO THE SHOULDER MUSCLE**
1 Scapula
2 Teres major
3 Humerus
4 Latissimus dorsi

c **AGONISTIC MUSCLE ACTION**
Movement is produced by muscle action referred to as agonism, in which force is transmitted to part of the body in order to alter its position in space. In many cases, two or more muscles work together as joint agonists, each contributing force to the movement: for example, teres major, and latissimus dorsi both pull on the humerus (the bone of the upper arm) in order to draw the arm down toward the side of the body.

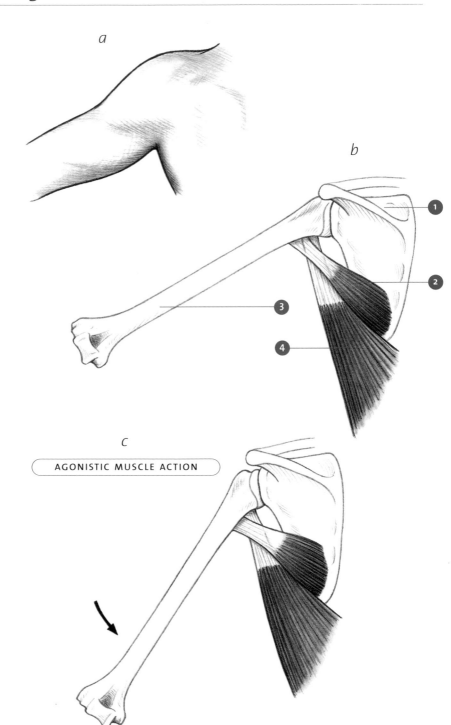

a

b

1
2
3
4

c

AGONISTIC MUSCLE ACTION

The arm muscles: antagonistic action

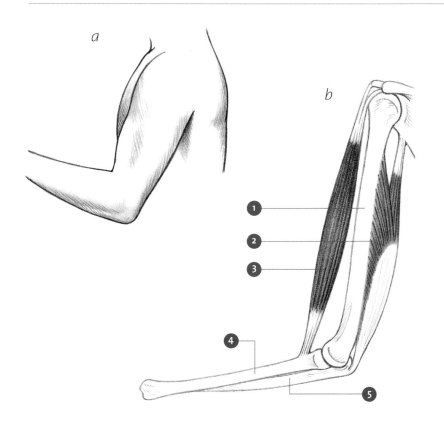

a

b

Individual muscles play different roles in different types of movements hence a muscle may act as an agonist in one movement, and as a stabilizer in another. Movements result from the coordinated action of several muscles, each fulfilling a particular role in creating the movement.

a **LOCATOR**
The side view of the arm

b **KEY TO THE UPPER ARM**
1 Humerus
2 Triceps
3 Biceps
4 Radius
5 Ulna

c **ANTAGONISTIC MUSCLE ACTION**
Many muscles are twinned with another muscle, known as an antagonist, that produces movement in the opposite direction. The muscles of the upper arm are antagonists of each other: biceps brachii bends the arm at the elbow, while triceps brachii straightens it. When one of these muscles contracts, its antagonist relaxes in order to allow movement to take place.

c

ANTAGONISTIC MUSCLE ACTION

20 Body types

The three typical body types

The overall appearance of the body can be described according to build and the relative prominence of the limbs and the trunk. A solidly built figure, in which the trunk stands out in relation to the musculature and limbs, is referred to as endomorphic, while ectomorphs are quite thin and have prominent arms and legs.

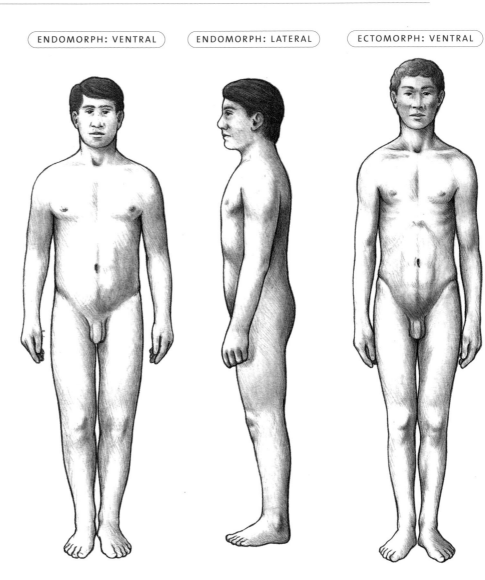

ENDOMORPH: VENTRAL ENDOMORPH: LATERAL ECTOMORPH: VENTRAL

The three typical body types

ECTOMORPH: LATERAL MESOMORPH: VENTRAL MESOMORPH: LATERAL

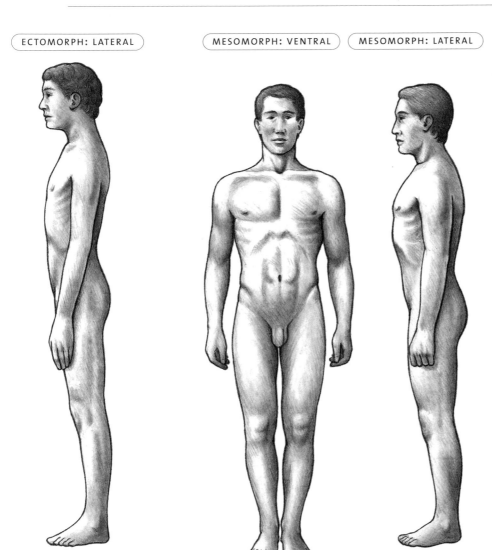

A person of intermediate build, with limbs and a trunk that are of similar prominence, may be described as a mesomorph.

THE HEAD AND NECK

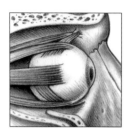
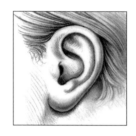
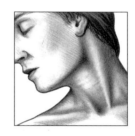

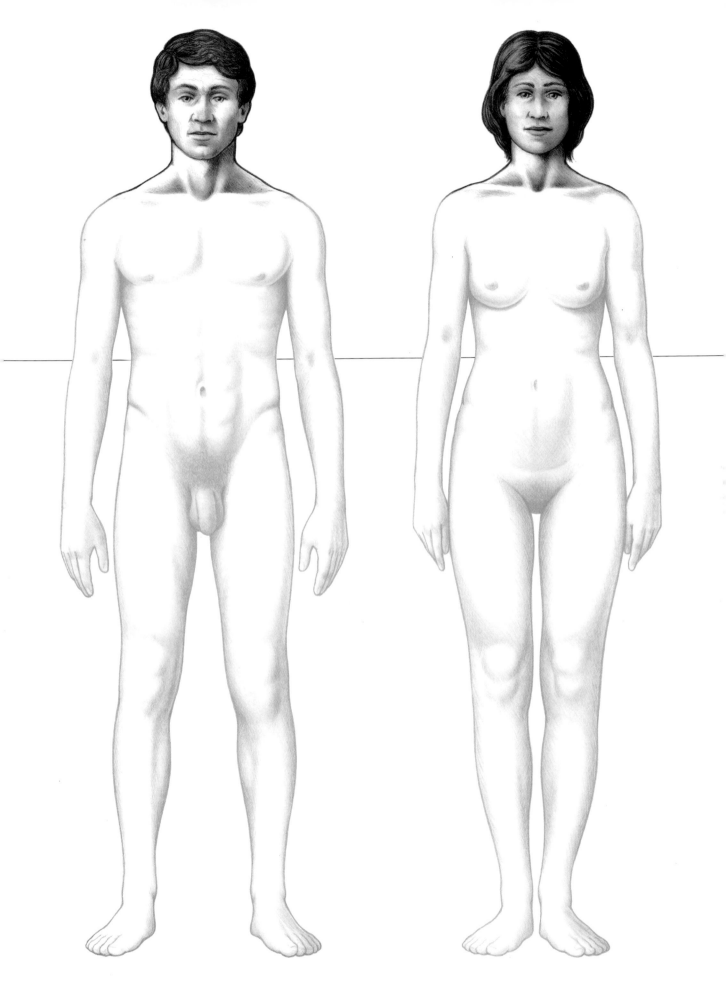

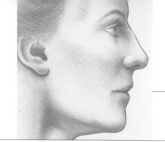

The head and neck

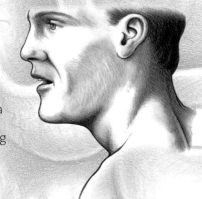

Female neck

Within the relatively small confines of the head are structures involved in an impressive variety of functions. Surrounded by the protective outer layers of the head is the brain, an organ of astonishing complexity that is responsible for thought, perception, and the ultimate control of all the body's activities. The skeleton of the head is the skull, which is composed of two contrasting parts: the neurocranium is the smoothly arching vault that provides a protective enclosure for the brain, and the viscerocranium is the intricate skeleton of the face. Within the recesses of the skull are housed delicate organs that produce four of the five senses: the eyes are responsible for vision, the ears detect sound, and the nose and mouth contain tiny receptors that allow us to taste and smell. Structures of the head are also involved in breathing and digestion. As air is inhaled through the nasal cavity, it is warmed, moistened, and filtered, preparing it for contact with the delicate tissues of the lungs. Food is mixed with saliva and broken down into smaller particles by the chewing movements of the jaw, so that it is ready to be swallowed.

Male profile

The front of the skull is covered by an intricate array of muscles that lie beneath the skin of the face. These muscles open and close the eyes, nostrils, and mouth, and produce subtle movements on the surface of the face: they are capable of contracting in a wide range of combinations, resulting in an enormous variety of facial expressions. For example, the muscle levator anguli oris, the name of which literally means "elevator of the corner of the mouth", is just one of a number of muscles that participate in smiling.

Elderly male
closeup

The neck contains the upper part of the spine, the trachea (windpipe), the esophagus (gullet), and blood vessels that run between the head and the chest. However, the neck does much more than merely connect the head to the rest of the body. In particular, much of the neck consists of muscles that not only support and move the head but are also involved in the action of swallowing. The neck also contains the larynx (voice box), which is a complex structure of cartilage and muscles that creates and modulates the sounds of the speech. Finally, the thyroid gland, which is located at the front of the neck, secretes hormones that have a variety of effects around the body.

Male jawline

Female profile

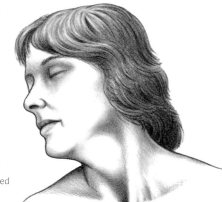

Female face
with eyes closed

Drawing tips

- Every head is unique. Start with the general outline and mark the position of the eyes, base of the nose, and the line of the mouth, checking that the angles and proportions are correct.

- The head of an older man has more character than that of a young girl, which will have less obvious features.

- A quick study of a head and neck with few lines can often work better than one that is fully rendered.

- Stronger shadows on the face and neck allow you to achieve more modeling, especially of the nose, mouth, and cheekbones. Look for obvious landmarks such as the suprasternal notch, border of the clavicles, and the thyroid cartilage.

26

The skull and face

Ventral view

The skull consists of an elaborate collection of bones that form the neurocranium (the smoothly rounded vault that houses the brain) and the viscerocranium (the skeleton of the face). Bones of the neurocranium fit together with tight stitchlike joints to provide a secure enclosure for the brain. The surface of the skull carries an array of small muscles that produce movements of the jaw and the wide range of expression that is characteristic of the human face.

a KEY TO THE BONES
OF THE SKULL (1)
1 Frontal bone
2 Nasal bone
3 Zygomatic arch
4 Maxilla
5 Mandible

b KEY TO THE MUSCLES
OF THE FACE
1 Frontalis
2 Temporalis
3 Orbicularis oculi
4 Procerus
5 Compressor naris
6 Masseter
7 Depressor anguli oris
8 Depressor labii
 inferioris
9 Mentalis

c KEY TO THE BONES
OF THE SKULL (2)
1 Nasal
2 Zygomatic
3 Maxilla
4 Mandible

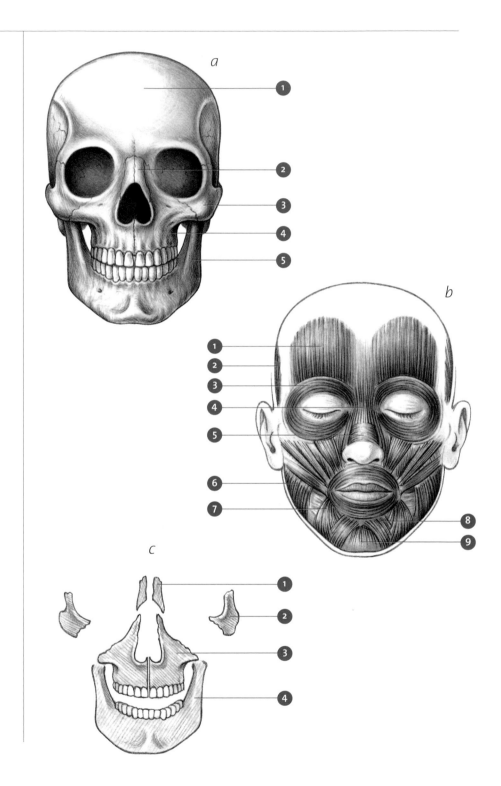

a

b

c

Lateral view

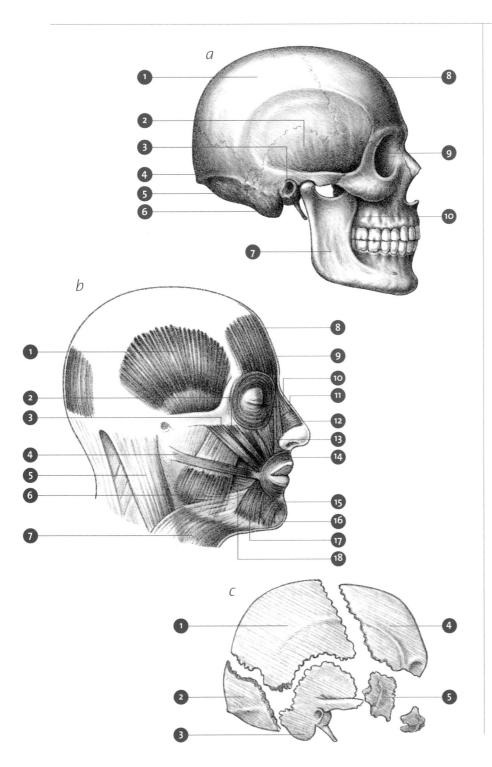

The mandible is attached to the remainder of the skull by loose joints that allow chewing movements to take place freely.

a **KEY TO THE BONES OF THE SKULL (1)**
1 Parietal bone
2 Temporal bone
3 External acoustic meatus
4 Superior nuchal line
5 Occipital bone
6 Mastoid process
7 Mandible
8 Frontal bone
9 Orbit
10 Maxilla

b **KEY TO THE MUSCLES OF THE HEAD**
1 Temporalis
2 Zygomaticus minor
3 Zygomaticus major
4 Risorius
5 Sternocleidomastoid
6 Masseter
7 Platysma
8 Frontalis
9 Orbicularis oculi
10 Procerus
11 Compressor naris
12 Levator labii superioris alaeque nasi
13 Levator labii superioris
14 Orbicularis oris
15 Depressor labii inferioris
16 Mentalis
17 Depressor anguli oris
18 Buccinator

c **KEY TO THE BONES OF THE SKULL (2)**
1 Parietal
2 Occipital
3 Temporal
4 Frontal
5 Sphenoid

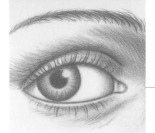

The eye

The parts and muscles of the eye

Light enters the eye through the pupil, which is regulated by a ring of muscle called the iris. The six muscles attached to the outer surface of the eyeball work to control the direction of the gaze. The front of the eye is surrounded by a circular muscle called orbicularis oculi, which closes the eye.

a KEY TO THE PARTS OF THE EYE
1 Sclera
2 Plica semilunaris
3 Medial canthus
4 Caruncle
5 Form of medial palpebral ligament
6 Iris
7 Pupil
8 Lateral canthus

b Side view of the eye

c KEY TO THE EYE MUSCLES
To show how the eye muscles hold and rotate the eye in its socket.
1 Superior oblique
2 Superior rectus
3 Lateral
4 Inferior oblique
5 Inferior rectus
6 Nasal bone
7 Bony orbit

d KEY TO THE EYE MUSCLES (EYE OPEN)
1 Orbicularis oculi
2 Medial palpebral ligament

e KEY TO THE EYE MUSCLES (EYE CLOSED)
1 Orbicularis oculi

PARTS OF THE EYE

a

SIDE VIEW OF EYE

b

EYE MUSCLES

c

d

e

29

Drawing the eyes

Many artists start a drawing or illustration by working up the eyes first before concentrating on the rest of the facial details. Although most of the eye is hidden from view in the orbit, it must be remembered that it is still a ball and is affected by light and shade. The part of the eye that is farthest from the light source will therefore need some tone on it. With the eye in its normal position, the lowest part of the iris touches the border of the lower lid.

STEP 1
Decide on the perspective and proportions. NOTE: there is the width of one eye between the eyes.

STEP 2
It is useful to develop the eyelids/irises/pupils first to make the eyes come alive. In addition, the position of the highlight is important. Use a strong line on the nose. NOTE: eyebrows are important in conveying an expression.

STEP 3
When you are satisfied with the central details, develop the planes and tones. NOTE: the line of the nose is stronger than the edge of the face.

STEP 4
The completed drawing. NOTE: the iris and pupil have slightly soft edges.

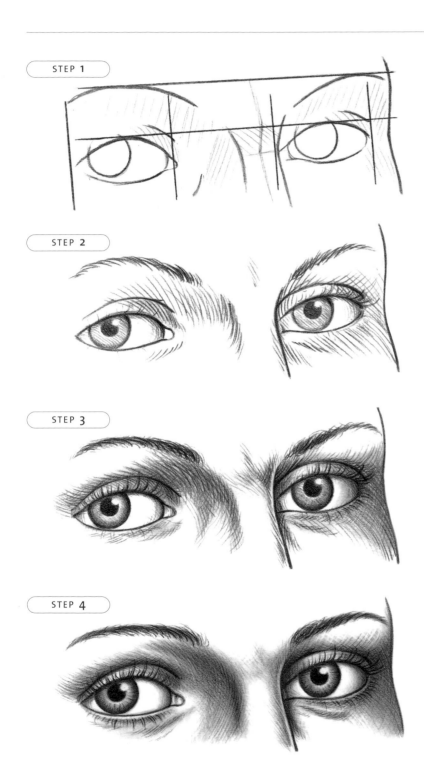

STEP 1

STEP 2

STEP 3

STEP 4

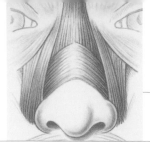

30

The nose

The bones and muscles of the nose

The nose is given its form by a rigid foundation of bone, to which is attached a collection of more flexible cartilages. One of these cartilages, the nasal septum, lies between the nostrils and separates the two nasal cavities. Covering the bones and cartilages of the nose are several muscles that alter the shape of the nostrils and contribute to facial expression.

a **KEY TO THE OUTER FORMS OF THE NOSE**
1. Outer form of nasal bone
2. Outer form of lateral nasal cartilage (can be slightly larger in male subjects)
3. Outer form of alar cartilages
4. Nostril
5. Philtrum

b **KEY TO THE NOSE BONES AND CARTILAGE**
1. Bony orbit
2. Nasal bone
3. Lateral nasal cartilage
4. Major alar cartilage
5. Minor alar cartilages
6. Septal cartilage

c **KEY TO THE NOSE MUSCLES**
1. Procerus
2. Compressor naris
3. Levator labii superioris alaeque nasi

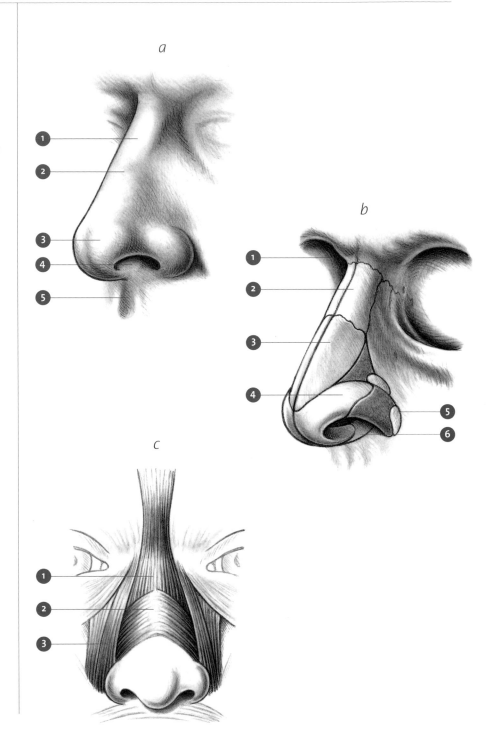

Drawing the nose

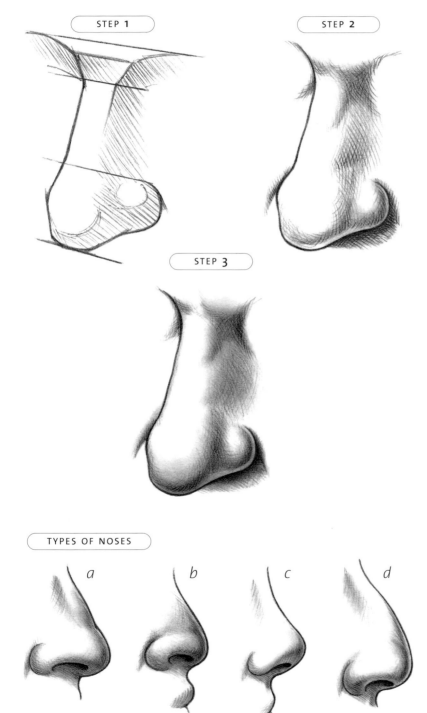

STEP 1

STEP 2

STEP 3

TYPES OF NOSES

a *b* *c* *d*

Try to imagine the structures shown in 30b when you come to figure out the planes of the nose, and to position it correctly in relation to the eyes. There may be a change of plane where the nasal bone joins the upper lateral cartilages, for example. The major alar cartilages give the end of the nose its unique shape, from bulbous to retroussé. The outline of the nose will often be the strongest feature on a face, but may be quite subtle on a young person, where most of the detail could be confined to the tip and nostrils only.

STEP 1
Establish the perspective, proportions, and main areas of light and shade.

STEP 2
Look for strong or obvious lines and start building up the main tonal areas, based on the structure.

STEP 3
Develop the darkest areas and strong lines of the nose (nearest to the eye of the viewer). Soften the tones and develop the highlights.

KEY TO THE TYPES OF NOSES
a Common shape
b Flat
c Retroussé
d Aquiline

32

Mouth and lips

The muscles of the mouth

A large number of muscles converge around the edges of the mouth. As a result, the soft tissues of the mouth are highly mobile, allowing subtle movements of facial expression and speech to take place. Orbicularis oris is a circular muscle that surrounds the mouth and is capable of closing the lips forcefully.

a **KEY TO THE MOUTH MUSCLES: VENTRAL**
1 Orbicularis oris
2 Zygomatous major and minor
3 Risorius
4 Depressor labii inferioris
5 Mentalis
6 Levator labii superioris alaeque nasi
7 Levator labii superioris
8 Depressor anguli oris

b **KEY TO THE MOUTH MUSCLES: LATERAL**
1 Levator labii superioris
2 Levator labii superioris alaeque nasi
3 Orbicularis oris
4 Depressor anguli oris
5 Mentalis
6 Depressor labii inferioris

c **KEY TO THE MOUTH MUSCLES: MEDIAL**
1 Orbicularis oris
2 Soft tissue lining of lips
3 Buccinator
4 Platysma
5 Mentalis

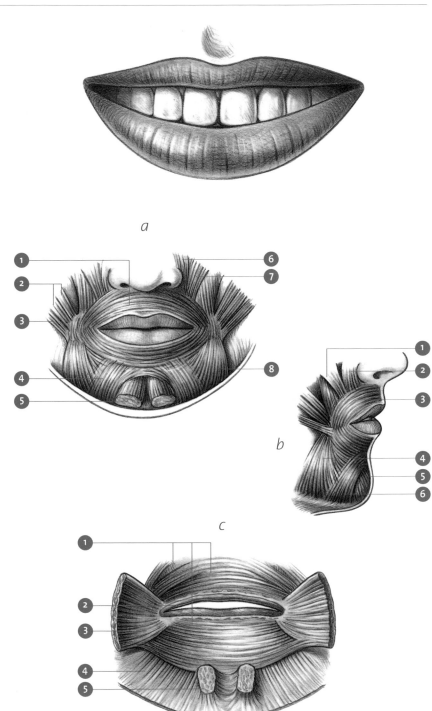

a

b

c

Drawing the mouth

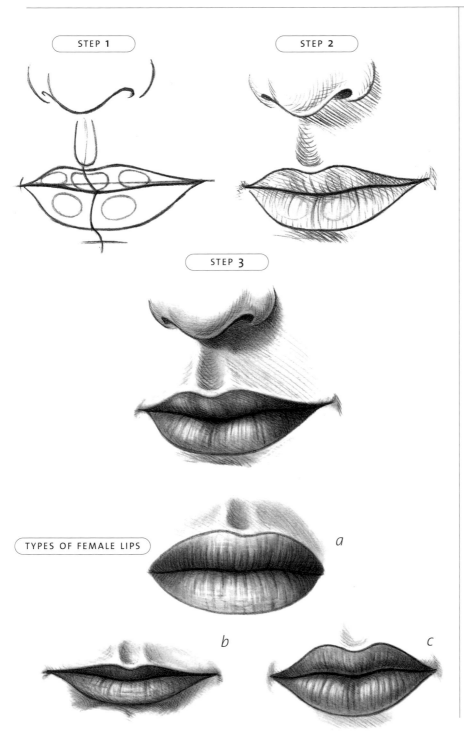

STEP 1

STEP 2

STEP 3

TYPES OF FEMALE LIPS

a

b

c

The line of the mouth is the most important, and the lips can be subtly suggested with very few lines or just tone only. The appearance of the lips can vary greatly according to the age, sex, and ethnic origin of an individual. It is useful to study how the form of the mouth and lips changes in profile compared to the front view.

STEP 1
The perspective, form, and shades within the lips, which determine the highlighted areas.

STEP 2
Develop the form and texture. NOTE: the midline is the strongest line.

STEP 3
Build up the tones. Soften and add highlights with a putty eraser. NOTE: remember to include the shadow under the top lip.

KEY TO TYPES OF FEMALE LIPS
a Full
b Older woman
c Young girl

The ear

The parts and muscles of the ear

The external ear consists of the external acoustic meatus (outer ear canal) and the auricle, which is the structure that surrounds the opening of the meatus. The auricle collects sound vibrations and directs them toward the ear canal. Its characteristic shape is created by cartilage located just beneath a covering of skin.

a **KEY TO EAR PARTS**
1 Triangular fossa
2 External acoustic meatus
3 Tragus
4 Antitragus
5 Lobe
6 Helix
7 Antihelix

b **KEY TO THE EAR MUSCLES**
1 Auricularis superior
2 Auricularis posterior
3 Auricularis anterior

c **KEY TO EAR CARTILAGE**
1 Cartilage
2 Ear canal (external acoustic meatus)
3 Cartilage

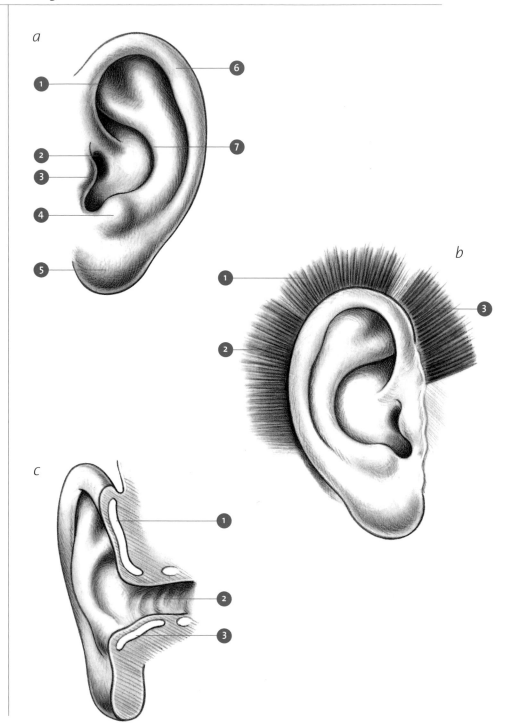

Drawing the ear

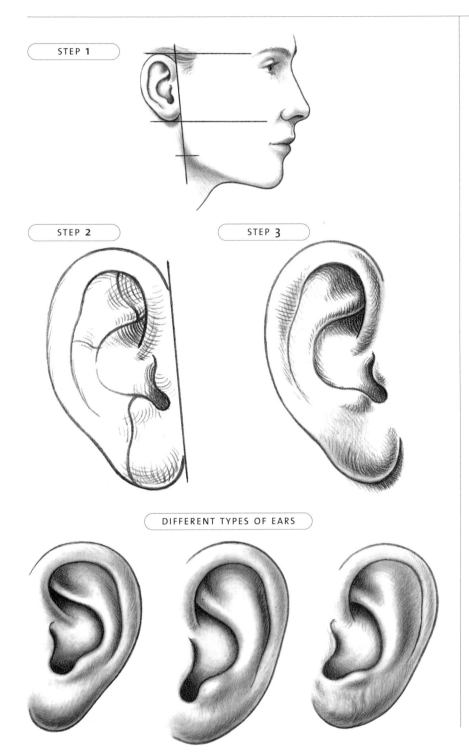

STEP 1

STEP 2

STEP 3

DIFFERENT TYPES OF EARS

Ears can be difficult to position correctly, but can easily detract from an otherwise pleasing study if not carefully drawn. The best way to determine their position is in relation to the jaw. As with other facial features, be aware that there is a great variety in the shape and size of ears.

STEP 1
This sketch shows the position of the ear in relation to the eyes and nose. NOTE: the distance from the ear lobe to the angle of the jaw is ½ a thumb's width, also that the angle of the ear is tilted back slightly.

STEP 2
This shows the different forms within the ear.

STEP 3
Here, forms are developed and the darkest and lightest areas are determined.

36

The mandible

The bones and muscles of the mandible

The mandible (jawbone) carries the lower teeth and is attached to the remainder of the skull by a mobile pair of joints. The angular form of the mandible and the muscles and tissues that surround it determine the shape of the chin. Several powerful muscles run between the mandible and the rest of the skull to give rise to the powerful movements of chewing.

a KEY TO THE MANDIBLE:
LATERAL
1 Head of mandible
2 Ramus of mandible
3 Oblique line
4 Angle of mandible
5 Coronoid process
6 Body of mandible
7 Alveolar part
8 Mental foramen
9 Mental protuberance

b KEY TO THE MANDIBLE:
VENTRAL
1 Incisors
2 Molars
3 Canine
4 Premolars

c KEY TO THE JAW
MUSCLES: LATERAL
1 Temporalis
2 Buccinator
3 Masseter

d KEY TO THE JAW
MUSCLES: VENTRAL
1 Temporalis
2 Masseter
3 Buccinator

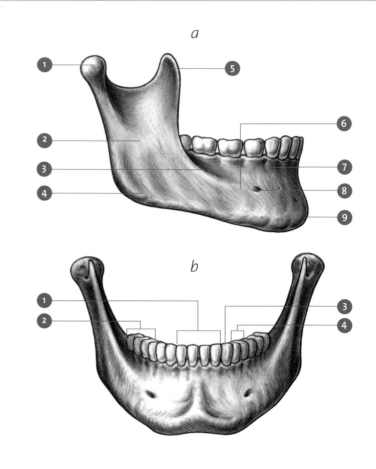

a

b

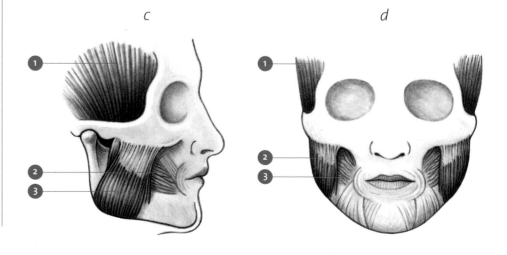

c

d

37

Drawing the jaw

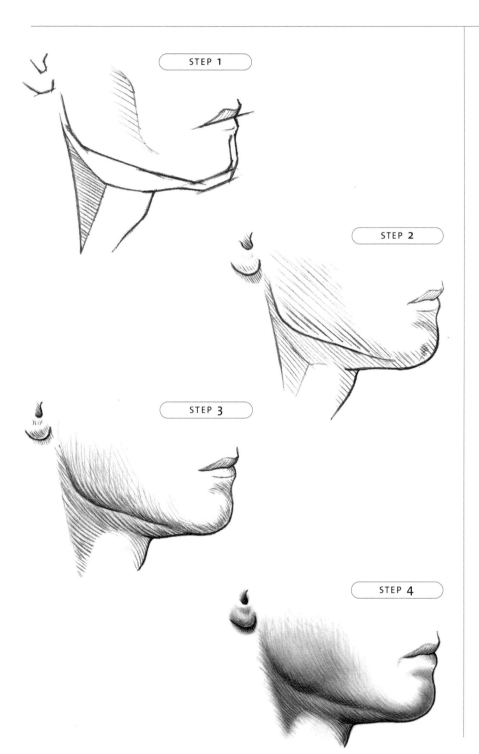

STEP 1

STEP 2

STEP 3

STEP 4

The form of the jaw can be quite subtle depending on the subject and the way that the light is falling on the planes of the face. Try doing some quick sketches of the jaw from different angles to familiarize yourself with its shape and relationship to the other structures of the head and neck.

STEP 1
NOTE: the relationship of the jaw to the anterior triangle of the neck, also to the ear and mouth. (Straight lines here show plane changes.)

STEP 2
Building up the main tonal areas on the jaw.

STEP 3
Developing the tones—reflected light under the jaw from the throat.

STEP 4
The sketch is complete.

38

The movement of the jaw

Drawing the jaw in motion

A set of muscles, called the muscles of mastication, is responsible for creating the chewing movements of the jaw. The jaw is capable of opening and closing, moving side to side, and protruding and retracting. Complex combinations of these actions take place during chewing. Mobile joints connect the two heads of the mandible with the rest of the skull, just in front of the ears.

a KEY TO OPENING THE JAW
1 Zygomatic arch
2 When the jaw is opened, the head of the mandible is carried forward (this can be felt as a bump below the zygomatic arch).

b LATERAL JAW MOVEMENTS
This jaw has moved over to the left, stretching the masseter muscle on the right side.

c KEY TO PROTRUSION OF THE JAW
1 In this subject, the jaw protrudes so that the lower teeth are in front of the upper teeth.
2 The mandible is pulled forward by the action of muscles called the lateral pterygoids.

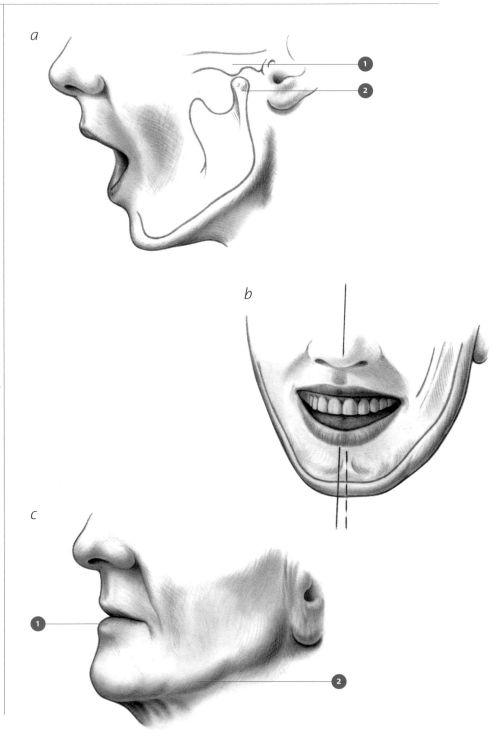

Drawing the chin and mouth

The appearance of the chin and mouth will be affected by the position of the mandible and the facial muscles.

DIFFERENT TYPES OF CHINS
a Middle-aged man
b Young woman
c Young man
d Woman

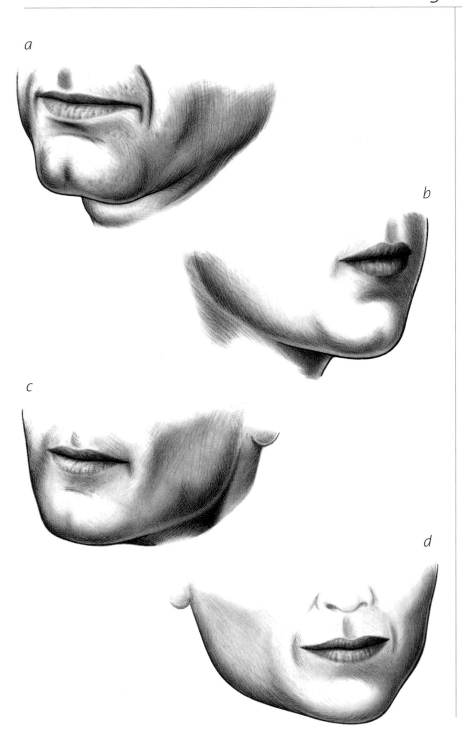

The neck

The muscles of the neck

a **KEY TO THE NECK MUSCLES: VENTRAL VIEW**
1 Anterior belly of digastric
2 Mylohyoid
3 Hyoid bone
4 Anterior triangle of neck
5 Sternocleidomastoid
6 Clavicular and sternal heads
7 Omohyoid
8 Sternohyoid
9 Thyroid cartilage
10 Trapezius
11 Omohyoid
12 Clavicle
13 Suprasternal notch

b **LATERAL VIEW**
1 Splenius capitis
2 Digastric
3 Levator scapulae
4 Scalenus (3)
5 Trapezius
6 Omohyoid
7 Clavicular head of sternocleidomastoid
8 Mylohyoid
9 Omohyoid
10 Sternohyoid
11 Sternocleidomastoid
12 Sternal head of sternocleidomastoid

c **DORSAL VIEW**
1 Nuchal line
2 Sternocleidomastoid
3 Splenius
4 Trapezius

d **KEY TO CROSS SECTION**
1 Thyroid gland
2 Trachea (windpipe)
3 Cervical vertebra
4 Spinal cord
5 Esophagus
6 Sternocleidomastoid
7 Scalemus anterior and medius muscles
8 Splenius capitis
9 Trapezius

a

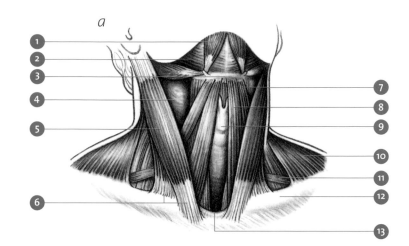

b

c

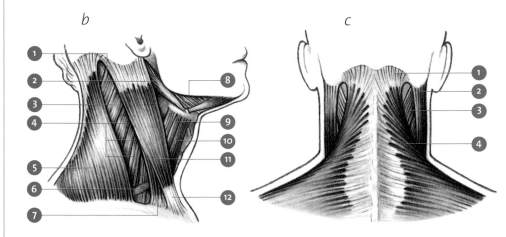

d

FRONT

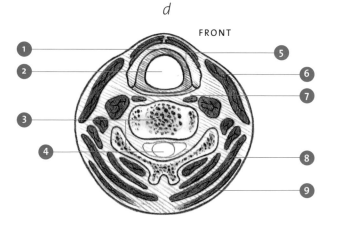

Drawing the neck

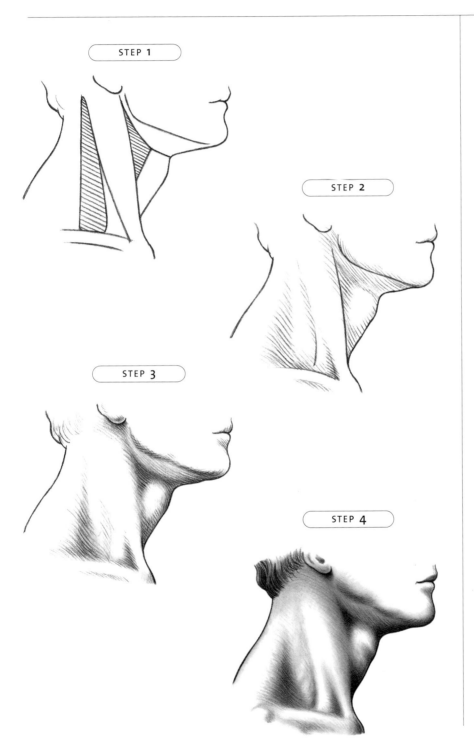

STEP 1

STEP 2

STEP 3

STEP 4

Necks can be strong and muscular or long and slender, and everything in between. As with the mouth, the neck can be suggested with just a few lines, and the most obvious feature may just be the attachment of the sternocleidomastoid muscle to the clavicle and sternum.

STEP 1
The basic structure of the neck: anterior and posterior triangles, position of trachea, jaw, and clavicle.

STEP 2
Starting to define the shapes within the neck and the outline of the thyroid and cricoid cartilages (these are more noticeable in male subjects).

STEP 3
Refining the shapes/forms, which may be quite subtle, depending on the position of the head. These are more obvious when the head is turned to one side, for example.

STEP 4
Complete the darkest areas and work on highlights using the putty eraser.

Drawing the head and face

Getting the proportions right

This is largely a matter of training the eye to see what looks right or wrong, and, after a little while, you may find that you can do this without too much conscious effort.

PROPORTIONS A
1 Divide the head into three equal parts (see the solid lines).
2 The eyes are at the halfway mark between the chin and the top of the head.

PROPORTIONS B
1 There is a distance of one eye between the eyes and the same width to the nostrils.
2 The vertical lines from the edge of the irises are the width of the mouth (when the irises are in the normal position of looking forward).

TAKING MEASUREMENTS
1 Hold your arm out straight in front of you, making sure that the pencil is parallel to your face.
2 Transfer the measurements to your paper, double checking that the basic measurements are correct.

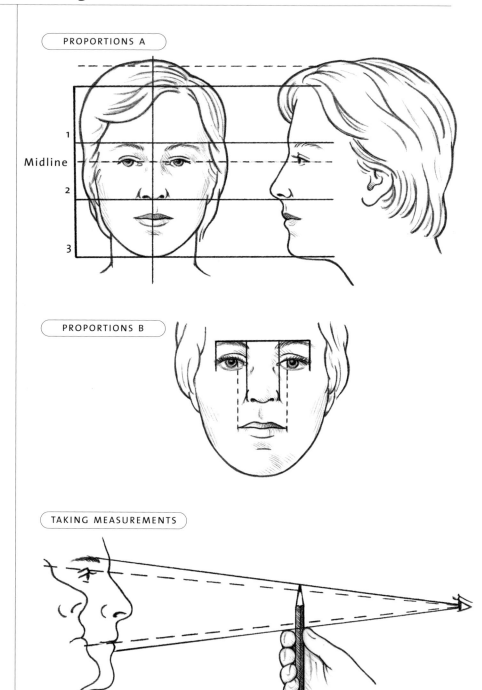

PROPORTIONS A

Midline

1

2

3

PROPORTIONS B

TAKING MEASUREMENTS

43

Drawing facial features

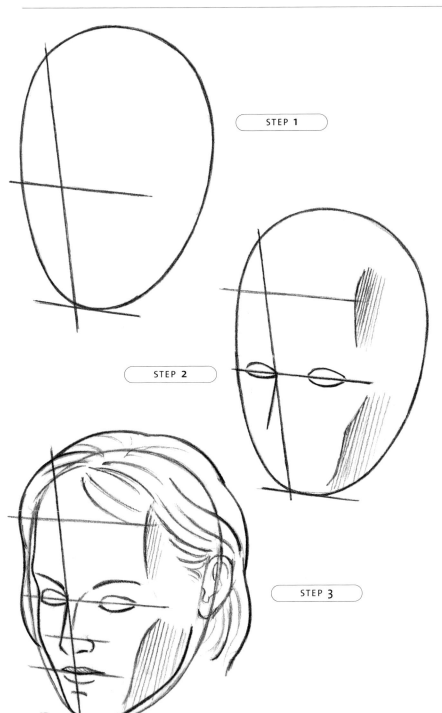

STEP 1

STEP 2

STEP 3

Using an egg shape is only one method of drawing the head, and, as with the general proportions, you should eventually be able to get the basic shapes right without constructing the head in this way.

STEP 1

1 Use the pencil to take measurements. Start by looking at the way the head is tilted or angled and draw a line that will be a midpoint from the chin to between the eyes.
2 Sketch in an oval for the head and place a line that will go through the corners of the eyes.
3 Mark the position of the chin and check the measurements again.

STEP 2

4 Draw a line to mark the position of the nose and draw the outlines for the eyes.
5 NOTE: sketch in the basic plane changes on the side of the face and top of the head.

STEP 3

6 Start filling in the outline shapes for the mouth, nose, eyebrows, shape of the face and ear, and check all the measurements again.
7 Start to build up the hair on the skull and develop the planes of the face, taking note of the direction of the light.

Different types of faces

Drawing detailed facial features

Most people have some distinctive features, such as creases and wrinkles, that can be used as a focal point and to make the face come alive.

a Side view of young male.

b Front view of elderly male.

c Female with slightly turned head.

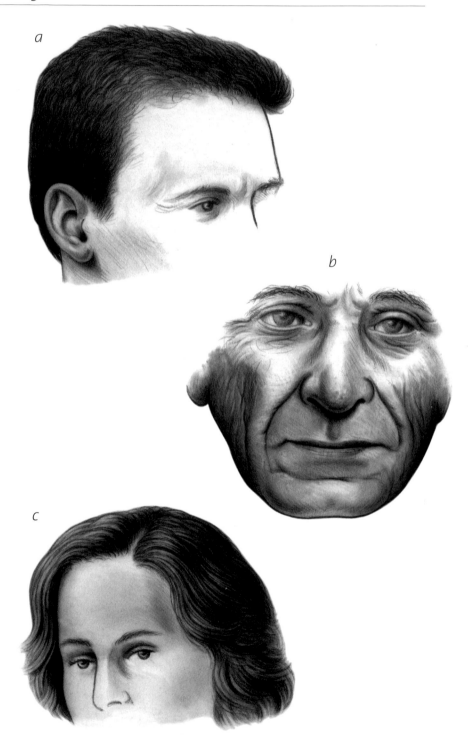

a

b

c

Drawing detailed facial features

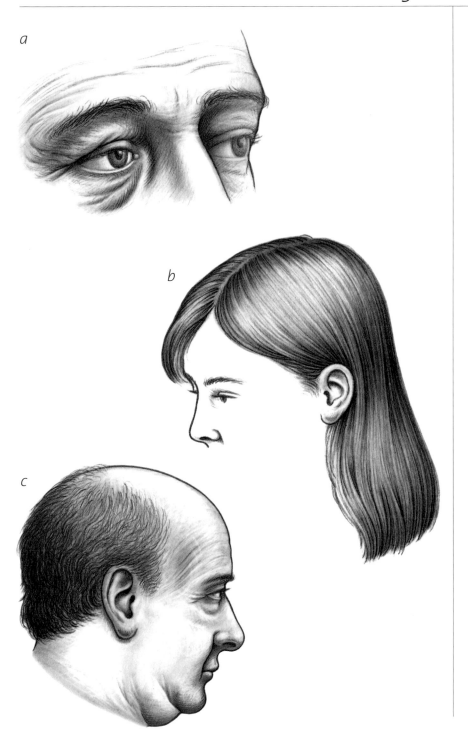

a

b

c

Hair can often be used as a frame for the face and may be the strongest element in a drawing, especially in young subjects whose smooth faces have yet to acquire some strong characteristics.

a Eyes of elderly male.

b Side view of young woman.

c Side view of elderly male.

THE TRUNK

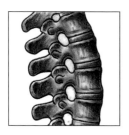 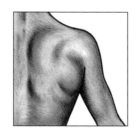 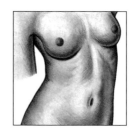 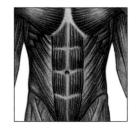

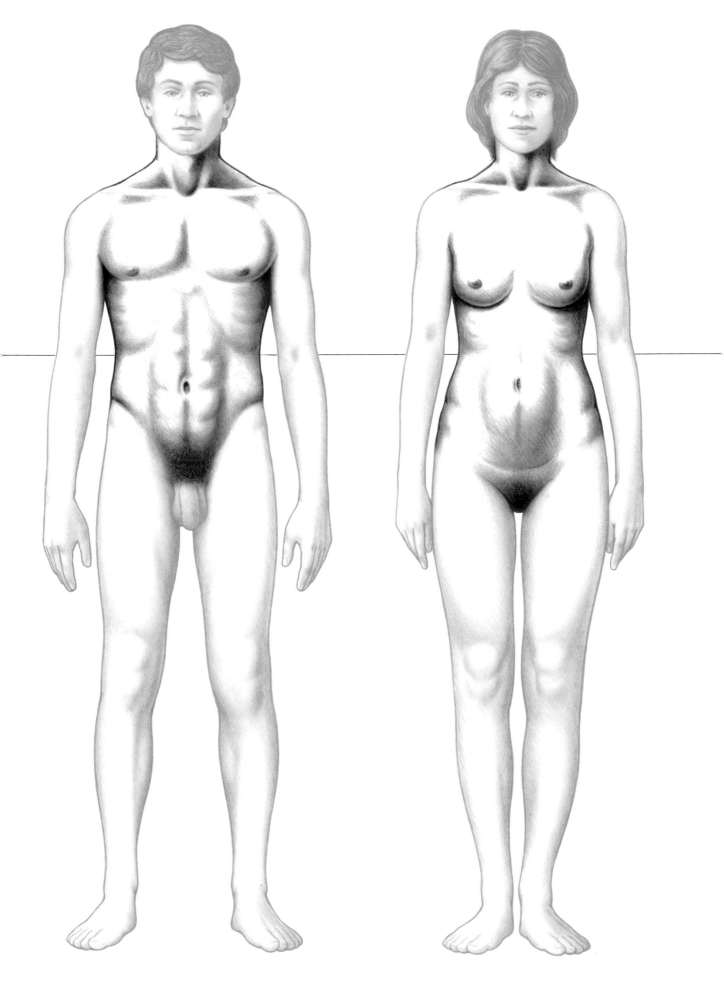

Introduction

Male torso

Housed within the bulky expanse of the trunk are organs concerned with the fundamental activities of the body: breathing, circulation of blood, digestion, and reproduction. The trunk consists of three parts—the thorax (chest), the abdomen, and the pelvic region. The major organs of the thorax are the heart and lungs. Oxygen-depleted blood is pumped by the muscular contractions of the heart to the lungs, where it is distributed through a vast array of tiny structures called alveoli, in which gases are transferred between the air and the blood. Freshly oxygenated blood flows back to the heart and is pumped around the body at a rate of about 317 quarts per hour—this rises to about 793 quarts per hour during strenuous exercise.

In the abdomen are the organs of digestion. Here, food is broken down by the churning action of the stomach into a loose paste called chyme. This substance is gradually released into the intestine, a coiled tube about 26 feet (8 metres) long, along which nutrients and water are absorbed into the bloodstream. The liver, pancreas, spleen, and kidneys are also found in the abdomen and perform a variety of roles, such as the production of digestive juices and the regulation of the body's fluid content.

Female back view

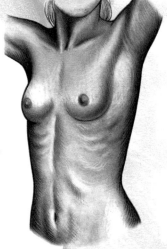

Female torso

The rectum and anus form the final part of the digestive tract and are located in the pelvic region. The bladder, which serves as a reservoir for urine until it can be released, is also found here, as are the reproductive organs: the ovaries, uterus, and vagina in women, and the testicles and penis in men.

Protection and support are provided by the skeleton of the trunk, which consists of the ribs, vertebral column, and pelvis. The ribs form a cage surrounding the organs of the thorax. Sheets of muscle lie between the ribs and allow the chest wall to rise and fall during breathing. The vertebral column runs down the back along the full length of the trunk, and the basinlike pelvis provides a rigid support for the lower part of the trunk, to which the legs are firmly anchored.

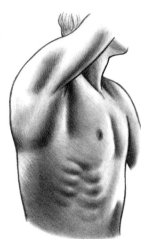

Male side view

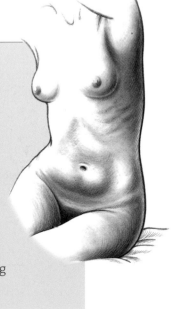

Male back view

Distinctive groups of muscles lie just beneath the surface of the trunk. The bulky pectoral muscles are found at the front of the chest—one beneath each nipple—and their form can be clearly seen in men; in women the pectoral muscles are generally concealed beneath the tissue of the breasts. In addition, fingerlike projections of muscle wrap around the sides of the trunk beneath the rib cage, and powerful strips of muscle run up and down the front of the abdomen, all contributing to the shape and movements of the trunk.

Female torso

Drawing tips

- If you are in an art class, move around to find an interesting viewpoint from which to commence your drawing.
- Start by doing some quick sketches, concentrating on the essential lines only, without putting in too much detail. The main tonal areas could be added using the pencil or charcoal almost flat on the surface of the paper.

- Try to imagine the underlying structures and look for obvious landmarks as described in the following pages. Make sure that you have these proportions figured out satisfactorily before starting on the rest of the figure.

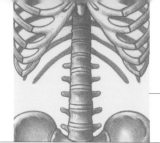

The skeleton of the trunk

Ventral view

The skeleton of the trunk consists of the rib cage, the vertebral column and the pelvis. The ribs form a cage-like structure that surrounds and protects the vital organs of the thorax. At the lower end of the trunk the pelvis, which is made up of the hip bones, sacrum, and coccyx, serves a similar role: it provides a basinlike enclosure for the organs of the pelvic region, and also anchors the trunk to the legs. Running up and down the length of the trunk is the vertebral column, which supports the posture of the trunk and extends upward into the neck.

TRUNK BONES: VENTRAL

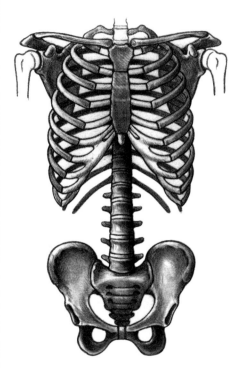

TRUNK EXTERNAL: VENTRAL

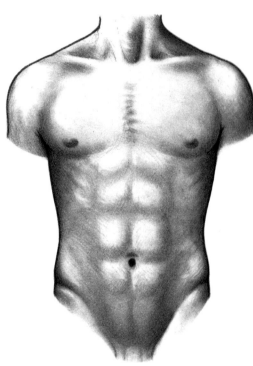

Lateral view

TRUNK BONES: LATERAL

TRUNK EXTERNAL: LATERAL

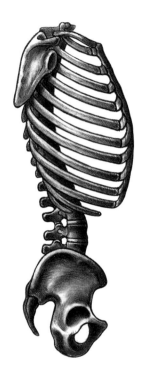

The rib cage consists of two sets of twelve ribs, which are attached at their posterior (back) ends to the vertebrae of the thorax. The anterior (front) ends of all but the lower two ribs on each side are connected to the sternum (breastbone) by lengths of cartilage called costal cartilages. The lowest parts of the vertebral column consist of the sacrum and the coccyx (tailbone), which attach to the hipbones to form the pelvis.

52

The trunk

The skeleton of the rib cage and sternum

The sternum (breastbone) consists of three parts: the manubrium, the body, and the xiphoid process. The manubrium and body meet at the sternal angle, which can be felt in a living person as a ridge at the front of the chest. The costal cartilages connect to the sternum at the costal notches. The lower two ribs on each side are not anchored to the sternum by costal cartilages and are called floating ribs.

a **KEY TO THE BONES OF THE RIB CAGE**
1 Suprasternal notch
2 Clavicle
3 Manubrium of sternum
4 Costochondral junction
5 Body of sternum
6 Xiphoid process
7 Vertebral column
8 Floating ribs (eleventh and twelfth ribs)

b **KEY TO THE STERNUM**
1 Suprasternal notch
2 Clavicular notch
3 Manubrium of sternum
4 Sternal angle
5 Costal notches
6 Body of sternum
7 Xiphisternal junction
8 Xiphoid process

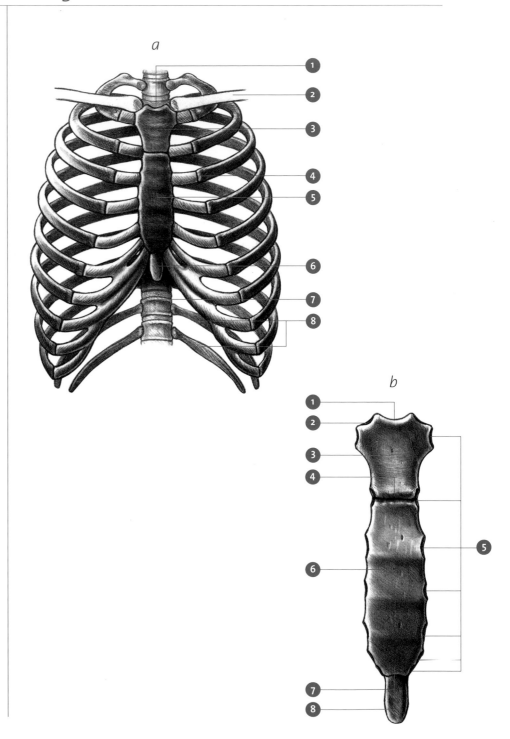

a

b

The ribs

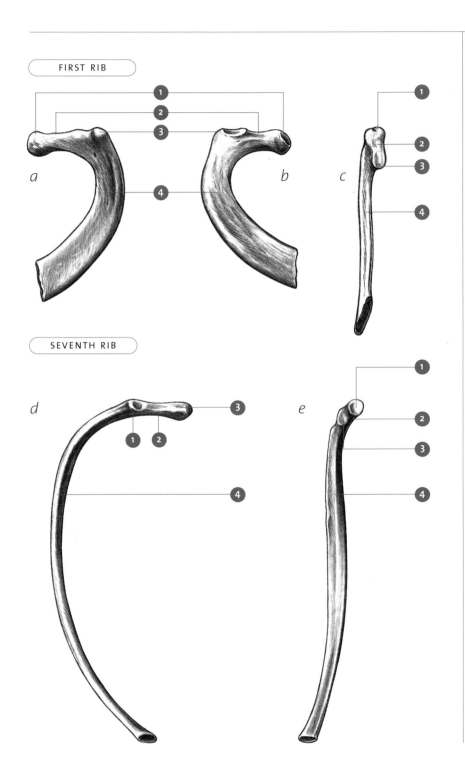

FIRST RIB

SEVENTH RIB

Each rib connects to the vertebral column at two points: the head and the tubercle. The shape of the ribs varies throughout the rib cage: the first rib is short and thick, but below it the ribs become progressively longer and more slender. The anterior (front) ends of the upper ten ribs are anchored to the sternum by the costal cartilages, whereas the anterior ends of the eleventh and twelfth ribs are free.

a KEY TO FIRST RIB:
CRANIAL VIEW
1 Head
2 Neck
3 Tubercle
4 Body

b KEY TO FIRST RIB:
CAUDAL VIEW
1 Head
2 Neck
3 Tubercle
4 Body

c KEY TO FIRST RIB:
MEDIAL VIEW
1 Tubercle
2 Neck
3 Head
4 Body

d KEY TO SEVENTH RIB:
CAUDAL VIEW
1 Tubercle
2 Neck
3 Head
4 Body

e KEY TO SEVENTH RIB:
MEDIAL VIEW
1 Head
2 Neck
3 Tubercle
4 Body

54

The spine

Ventral view

The vertebral column consists of twenty four vertebrae, the sacrum, and the coccyx, and has three functions: it protects the spinal cord, provides an anchoring point for the ribs, and gives postural support to the upper body. Between the vertebrae are cushions of tissue called intervertebral disks, which act as shock absorbers and give the vertebral column flexibility. The upper seven vertebrae are located in the neck, and the first vertebra, called the atlas, connects to the skull. The twelve vertebrae of the thorax provide anchoring points for the ribs. Farther down the vertebral column are the five lumbar verterbrae: these are particularly large, since they support more weight than the upper vertebrae. At the base of the vertebral column are the sacrum and coccyx (tailbone), the bones of which are fused together in the adult.

**KEY TO THE BONES OF
THE SPINE: VENTRAL**
1 Atlas
2 Axis
3 Intervertebral disks
4 Cervical vertebrae (7)
5 Thoracic vertebrae (12)
6 Lumbar vertebrae (5)
7 Sacrum
8 Coccyx

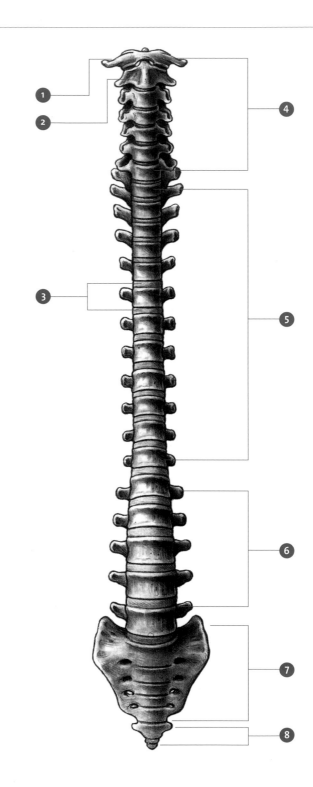

Lateral view

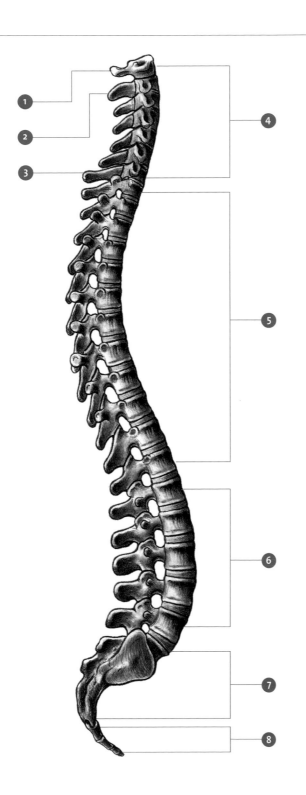

Viewed from the side, the vertebral column can be seen to curve gracefully along its length, which improves its ability to bear the weight in the upper body. Projecting from the posterior (back) surface of most of the vertebrae is a spike of bone called the spinous process. This is particularly prominent in the seventh vertebra, the spinous process of which can be felt beneath the skin at the back of the neck.

**KEY TO THE BONES OF
THE SPINE: LATERAL**
1 Atlas
2 Axis
3 Spinous process of C7
4 Cervical vertebrae (7)
5 Thoracic vertebrae (12)
6 Lumbar vertebrae (5)
7 Sacrum
8 Coccyx

56

The spine

Dorsal view

A spike of bone called the transverse process projects from either side of each vertebra. In the thoracic vertebrae, the transverse processes are anchored to the tubercles of the ribs, and at all levels of the vertebral column they provide points of attachment for the muscles of the back. The fifth lumbar vertebra connects to the sacrum, which in turn connects to the coccyx.

KEY TO THE BONES OF THE SPINE: DORSAL
1 Atlas
2 Axis
3 Spinous process of C7
4 Cervical vertebrae (7)
5 Thoracic vertebrae (12)
6 Lumbar vertebrae (5)
7 Sacrum
8 Coccyx

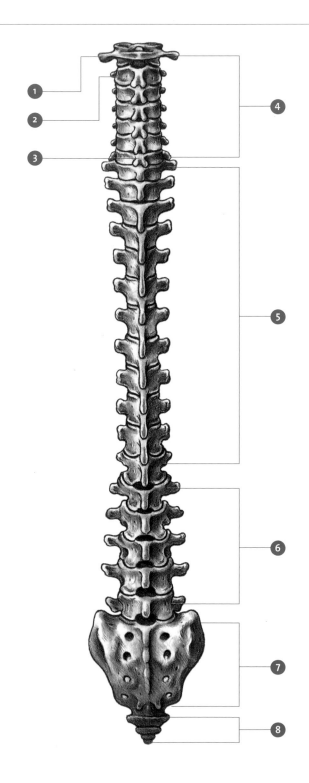

The first and second cervical vertebrae

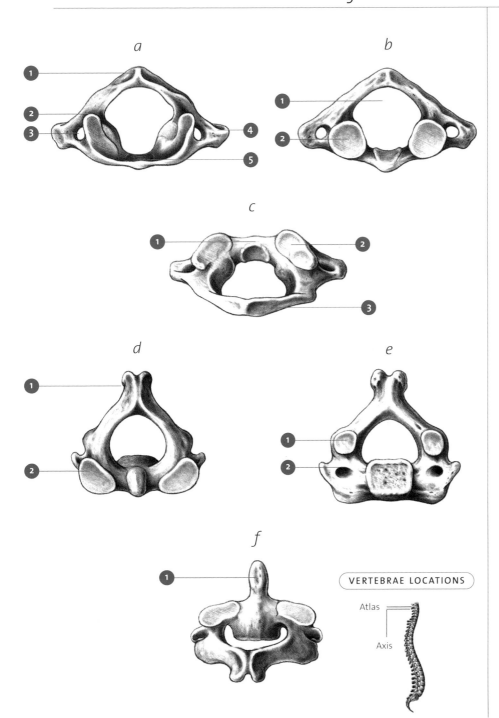

a

1
2
3
4
5

b

1
2

c

1
2
3

d

1
2

e

1
2

f

1

VERTEBRAE LOCATIONS

Atlas

Axis

The uppermost two vertebrae are specially designed to allow the head to rotate freely on the neck. A spike of bone called the dens projects upward from the axis into the vertebral foramen of the atlas. Here, a ligament holds the dens against the inner surface of the anterior tubercle, forming a pivot for rotation of the head.

a **KEY TO FIRST CERVICAL VERTEBRA (ATLAS): CRANIAL VIEW**
1 Posterior tubercle
2 Superior articular facet
3 Transverse foramen
4 Transverse process
5 Anterior tubercle

b **KEY TO FIRST CERVICAL VERTEBRA: CAUDAL VIEW**
1 Vertabral foramen
2 Inferior articular facet

c **KEY TO SECOND CERVICAL VERTEBRA (AXIS): CRANIAL VIEW**
1 Spinous process
2 Superior articular facet
3 Dens (odontoid process)

d **KEY TO SECOND CERVICAL VERTEBRA: CAUDAL VIEW**
1 Inferior articular facet
2 Transverse foramen

e **KEY TO SECOND CERVICAL VERTEBRA: DORSAL VIEW**
1 Dens (odontoid process)
2 Transverse process

f **KEY TO SECOND CERVICAL VERTEBRA: MEDIAL VIEW**
1 Dens (odontoid process)

The upper back

The muscles of the upper back

Several columns of muscles run up and down the back, in order to support the spine and produce movements of the trunk, head, and neck. In the uppermost part of the back, these muscles arise from the vertebrae and ribs, and attach to the bones of the neck and occiput (the back of the head). When muscles on both sides of the neck work together, the head tilts back, as when gazing at the sky. Tilting of the head and neck to one side occurs when the muscles contract on that side of the neck only.

a SPLENIUS MUSCLE **1**
Splenius capitis

b SPLENIUS MUSCLE **2**
Splenius cervicus

c SEMISPINALIS MUSCLE
Semispinalis capitis

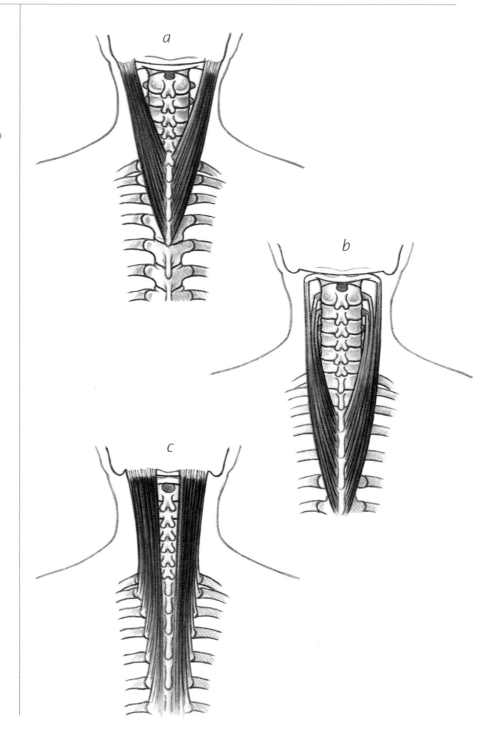

The muscles of the back

ERECTOR SPINAE MUSCLES

The erector spinae muscles are one of the groups of muscles that run up and down the length of the back. They arise at the very base of the spine, from the sacrum, and pelvis. As they run up the back, they form three individual muscles: spinalis, which lies alongside the spinal column, iliocostalis, which extends up the back of the rib cage, and longissimus, which is found between the other two. The erector spinae muscles straighten the back and hold it upright, and contribute to movements of the trunk.

KEY TO THE ERECTOR SPINAE MUSCLES
1 Rib cage
2 Spinalis
3 Longissimus
4 Iliocostalis

60

The thorax

Lateral view

The rib cage forms a barrel-shaped enclosure surrounding the internal organs of the thorax. When breathing out, the ribs are angled downward, as shown in this drawing. During inspiration the front of the rib cage swings upward and outward, causing the chest to expand.

KEY TO THE BONES OF THE THORAX: LATERAL
1 First rib
2 Spinous processes of vertebrae
3 Manubrium of sternum
4 Sternal angle
5 Body of sternum
6 Costal cartilages
7 Floating ribs

THORAX: LATERAL

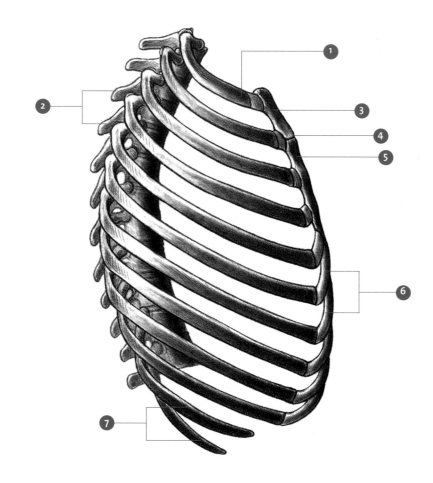

Dorsal view

The posterior (back) ends of the ribs are attached to the vertebral column. The head of each rib is connected to one or more vertebrae, and the tubercle of each rib attaches to the transverse process, providing additional support.

KEY TO THE BONES OF THE THORAX: DORSAL
1 C7 vertebra
2 T1 vertebra
3 First rib
4 Spinous process of vertebrae
5 Transverse processes of vertebrae
6 Tubercles of ribs
7 Floating ribs
8 L1 vertebra

THORAX: DORSAL

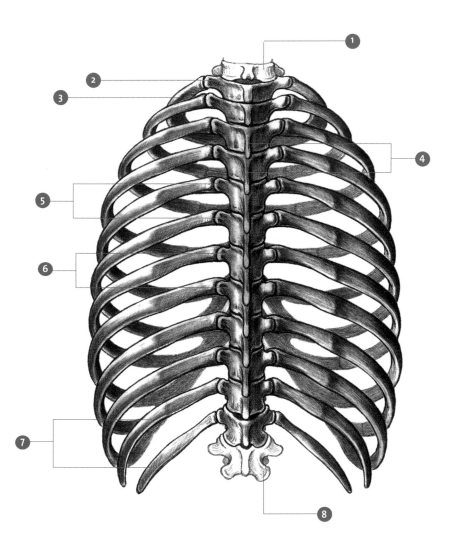

62

The back

The skeleton of the back

The skeleton of the back consists of two components: the vertebrae and the ribs. The vertebrae are stacked on top of each other to form a column of bone that supports the back and protects the spinal cord. Separating each of the vertebrae are the intervertebral disks, which act as shock absorbers and give the spine flexibility. Spikes of bone called processes project from each vertebra to provide anchoring points for the muscles of the back. The upper vertebrae connect to the ribs, which form the rib cage: this too acts as an anchoring point for muscles of the back, and protects the internal organs of the thorax. At the base of the vertebral column are the sacrum and coccyx, which form part of the pelvis.

KEY TO THE SKELETON OF THE BACK: DORSAL VIEW
1 Clavicle
2 Scapula
3 Humerus
4 Rib cage
5 Thoracic vertebrae
6 Lumbar vertebrae
7 Hip bone
8 Sacrum

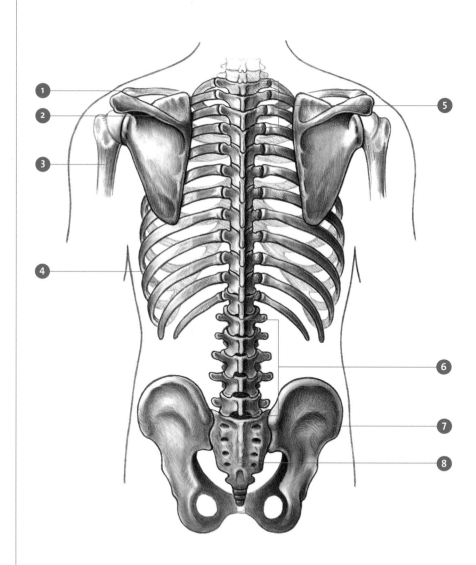

The muscles of the back

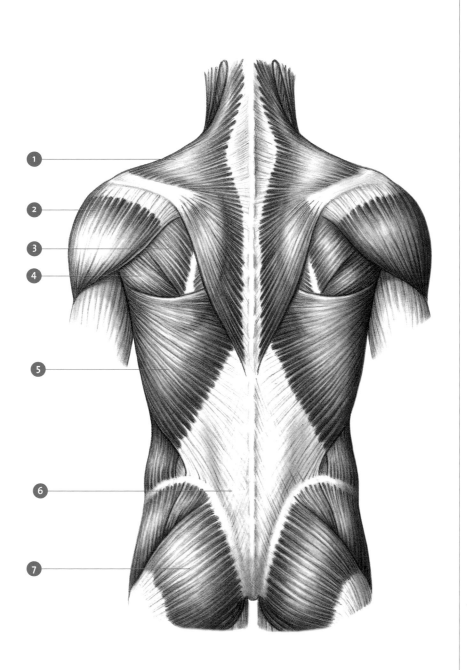

Covering the deeper muscles of the back are several sheetlike muscles that lie just beneath the skin and give the back its distinctive contours. Trapezius is a lozenge-shaped muscle that arises in the center of the back, spreads to the shoulders, and then converges again on the neck. Farther down the back is latissimus dorsi, which wraps around the sides of the trunk. Gluteus maximus forms the rounded shape of the buttock and acts upon the hip joint.

KEY TO THE MUSCLES OF THE BACK
1 Trapezius
2 Deltoid
3 Infraspinatus
4 Teres major
5 Latissimus dorsi
6 Form of erector spinae muscles under aponeurosis of latissimus dorsi
7 Gluteus maximus

The back

Drawing the back

The spine forms a conveniently strong line, upon which the other structures may be built up. Note the plane changes that occur as the spine runs from the neck to the pelvis.

STEP 1
Drawing in landmarks: the curve of the spine, the position of the rib cage, the scapulae, and the hips.

STEP 2
Developing tones and the position of the back muscles (sacrospinalis).

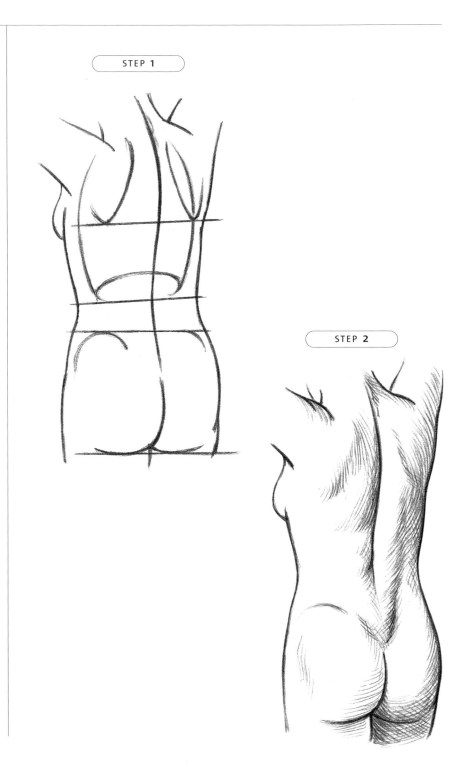

STEP 1

STEP 2

Drawing the back

The appearance of the bones and muscles of the back will vary greatly according to the position of the figure. There may be some bunching of the muscles that attach to the scapulae, for example, and some of the spinous processes may be more or less visible, as in this drawing where the spine of the seventh cervical vertebra is prominent.

STEP 3
Developing form and tones, displaying the direction of light.

STEP 4
Finishing with the darkest areas and removing tones for highlights with a putty eraser.

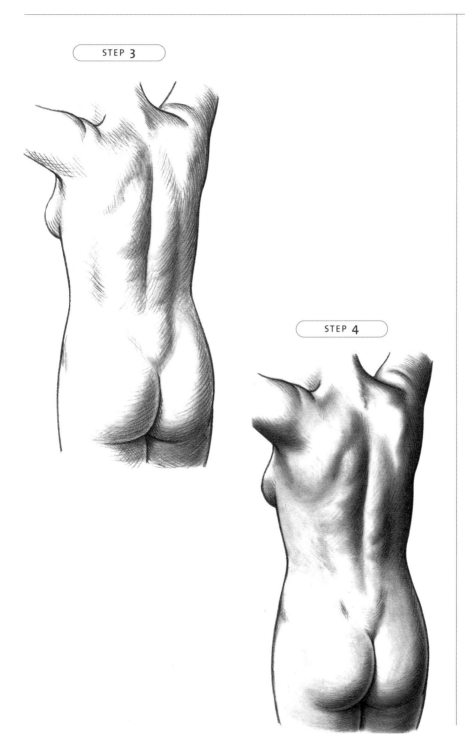

STEP 3

STEP 4

The shoulder

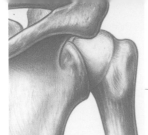

The skeleton of the shoulder

The skeleton of the shoulder consists of two bones: the clavicle (collarbone) and the scapula (shoulder blade). The clavicle is an elongated, gently curving bone that is attached at one end to the upper part of the sternum (breastbone). The other end of the clavicle connects to the acromion, which is a knob of bone that extends from the upper part of the scapula. The scapula consists of a thin triangular plate of bone that is loosely held against the back of the rib cage. At the outer corner of the scapula is a cuplike depression called the glenoid cavity, into which the ball-like head of the humerus rests in order to form the shoulder joint.

a KEY TO THE BONES OF THE SHOULDER: VENTRAL VIEW
1 Clavicle
2 Acromion
3 Coracoid process
4 Head of the humerus
5 Shaft of the humerus
6 Scapula

b KEY TO THE BONES OF THE SHOULDER: LATERAL VIEW
1 Spine of scapula
2 Acromion
3 Clavicle
4 Humerus
5 Scapula
6 Head of humerus resting in glenoid cavity

c KEY TO THE BONES OF THE SHOULDER: DORSAL VIEW
1 Acromion
2 Spine of scapula
3 Clavicle
4 Scapula
5 Head of humerus

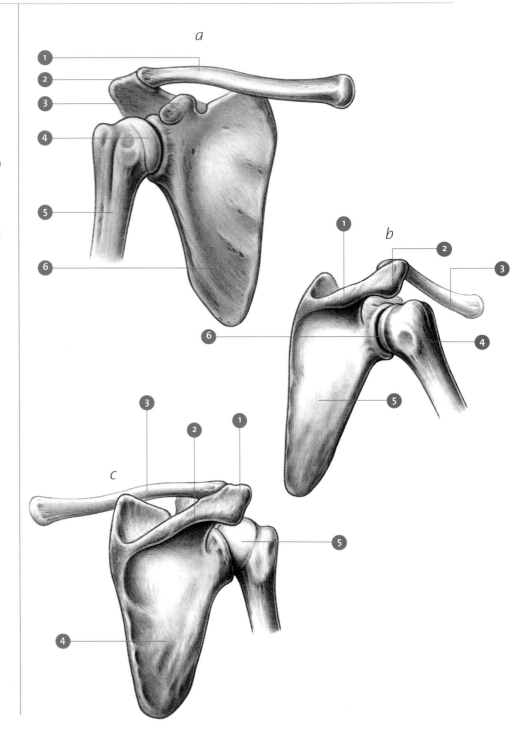

The muscles of the shoulder

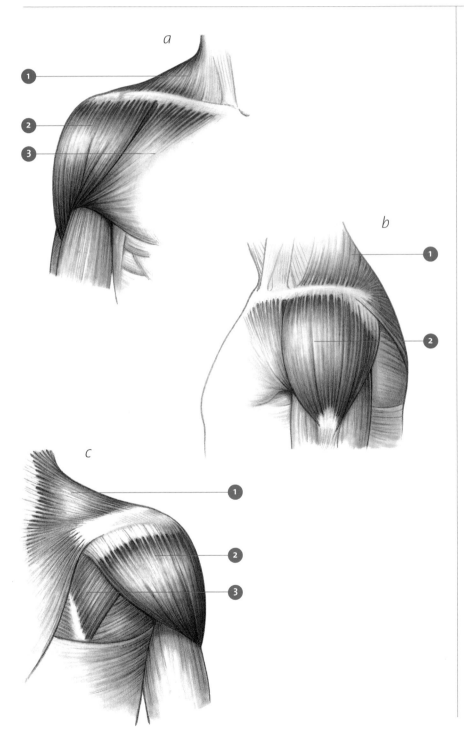

a

b

c

Numerous muscles surround the shoulder, giving it its distinctive bulk and shape. Several of these muscles, such as the trapezius and pectoralis minor, run between the axial skeleton and the scapula: they alter the position of the scapula and hold it steady when the shoulder is bearing weight. Other muscles, such as the deltoid, infraspinatus, and pectoralis major, connect to the upper part of the humerus. These muscles hold the head of the humerus firmly within the glenoid cavity, and produce the movements of the shoulder joint.

a **KEY TO THE MUSCLES OF THE SHOULDER: VENTRAL VIEW**
1 Trapezius
2 Deltoid
3 Pectoralis major

b **KEY TO THE MUSCLES OF THE SHOULDER: LATERAL VIEW**
1 Trapezius
2 Deltoid

c **KEY TO THE MUSCLES OF THE SHOULDER: DORSAL VIEW**
1 Trapezius
2 Deltoid
3 Infraspinatus

68

The shoulder

Drawing the shoulder

Since you would probably be drawing the head and shoulders together, it is important to get the basic proportions looking right. Check that the distance from the suprasternal notch to the edge of the shoulder is one head's length, as shown on page 152.

STEP 1
Establishing landmarks: the triangle of the clavicle, the central line through the sternum, the chest, and the position of the arm.

STEP 2
Establishing planes.

STEP 1

STEP 2

Drawing the shoulder

The suprasternal notch is the one landmark that is obvious in all individuals, and as such can be used as a starting point when figuring out the relationships of the other structures.

STEP 3
Gradually building up the planes and areas of light and shade (as before).
1 Acromioclavicular joint
2 Acromion process

STEP 4
The completed drawing.

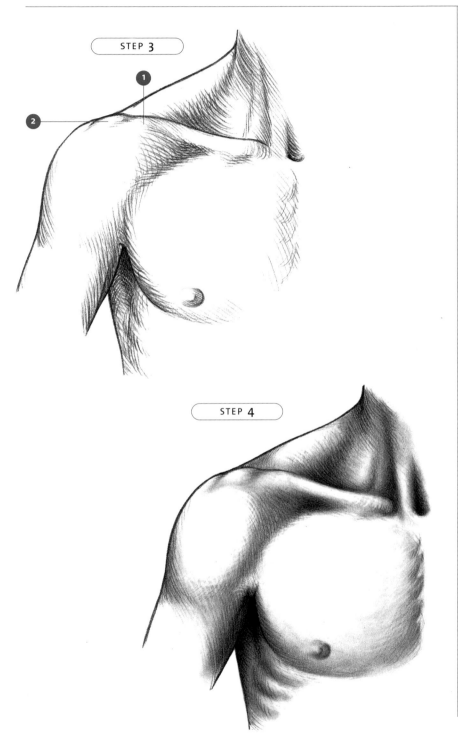

STEP 3

STEP 4

70

The shoulder girdle

The muscles of the shoulder girdle

The shoulder girdle consists of the clavicle, which runs horizontally out from the top of the sternum, and the scapula, which lies against the back of the rib cage. These bones meet at the acromioclavicular joint and connect the skeleton of the arm to the skeleton of the trunk.

KEY TO THE MUSCLES OF THE SHOULDER GIRDLE:
VENTRAL VIEW
1 Acromioclavicular joint
2 Acromion
3 Coracoid process
4 Glenoid cavity
5 Rib cage
6 Sternoclavicular joint
7 Intercostal muscles
8 Sternum
9 Xiphoid process

ANTERO-LATERAL VIEW
(This view is seen slightly from above.)
1 Scapula
2 Rib cage
3 Clavicle
4 Sternum

VENTRAL VIEW

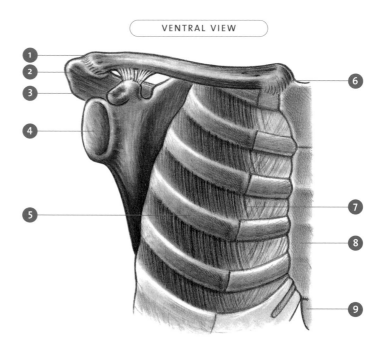

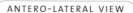

ANTERO-LATERAL VIEW

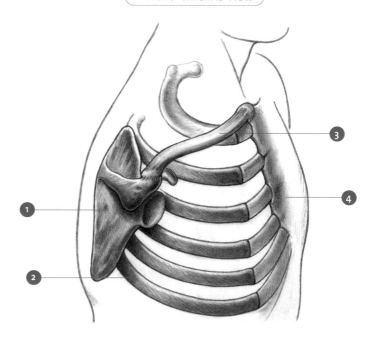

The muscles of the shoulder girdle

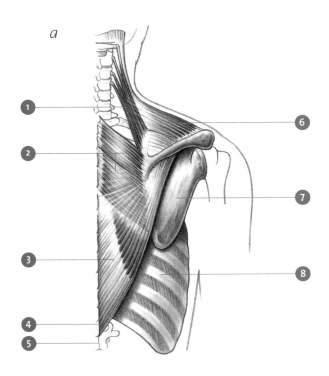

Several muscles connect the scapula to the trunk, anchoring it firmly to the body and shifting its position during movements of the shoulder and arm. Of these, trapezius, levator scapulae, and the rhomboids are muscles of the back, whereas serratus anterior, pectoralis minor, and subclavius (a small muscle that lies beneath the clavicle) are muscles of the chest.

a **KEY TO THE MUSCLES OF THE SHOULDER GIRDLE: DORSAL VIEW**
1 Levator scapulae
2 Rhomboid muscles (major and minor)
3 Trapezius over rhomboid muscles
4 T12 vertebra
5 L1 vertebra
6 Trapezius (ghosted over)
7 Scapula
8 Rib cage

b **KEY TO THE MUSCLES OF THE SHOULDER GIRDLE: LATERAL VIEW**
1 Glenoid cavity
2 Scapula
3 Serratus anterior
4 Pectoralis minor
5 Sternum
6 Intercostal muscles

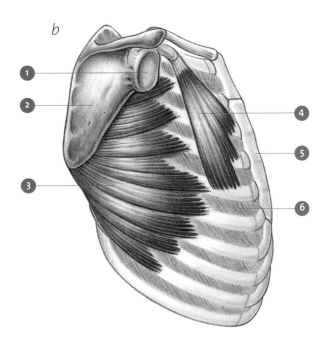

The pectoral region

The pectoral muscles

Pectoralis major is a large fan-shaped muscle that arises from the clavicle, sternum, and costal cartilages. Its fibers converge upon the upper part of the humerus, producing powerful movements of the arm at the shoulder. The bulk of the pectoralis major can be seen beneath the skin of the chest, and is particularly prominent in men—in women it is not as large and is partially obscured by the breast. Pectoralis minor is hidden underneath pectoralis major and is much smaller: it runs from several of the upper ribs to the coracoid process of the scapula, and pulls the shoulder forward and down.

a **KEY TO PECTORALIS MAJOR: VENTRAL VIEW**
1 Clavicle
2 Pectoralis major
3 Costal cartilages
4 Humerus

b **KEY TO PECTORALIS MAJOR: LATERAL VIEW**
1 Scapula
2 Humerus
3 Pectoralis major

c **KEY TO PECTORALIS MINOR: VENTRAL VIEW**
1 Coracoid process of scapula
2 Pectoralis minor
3 Ribs
4 Humerus

d **KEY TO PECTORALIS MINOR: LATERAL VIEW**
1 Scapula
2 Humerus
3 Pectoralis minor

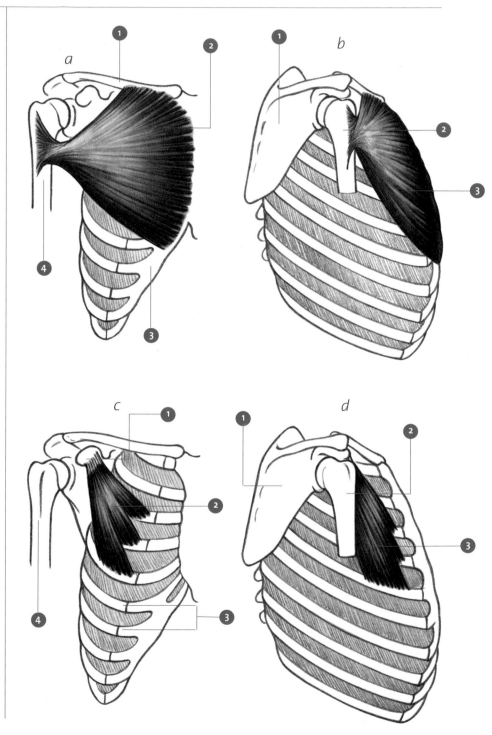

The shoulder and humerus

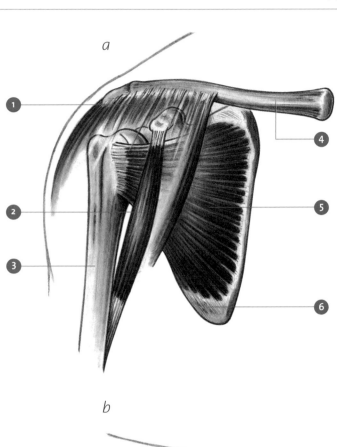

The scapula is enveloped in strips of muscle: its anterior surface is covered by subscapularis, its posterior surface by infraspinatus, teres minor, and teres major, and its superior surface by supraspinatus. All of these muscles are attached to the upper end of the humerus, which they act upon in order to rotate and bend the arm at the shoulder joint. Other shoulder muscles that attach to the humerus include deltoid and coracobrachialis.

a KEY TO THE SHOULDER AND HUMERUS: VENTRAL VIEW
1 Deltoid (ghosted over)
2 Coracobrachialis
3 Humerus
4 Clavicle
5 Subscapularis
6 Scapula

b KEY TO THE SHOULDER AND HUMERUS: DORSAL VIEW
1 Supraspinatus
2 Infraspinatus
3 Teres minor
4 Teres major

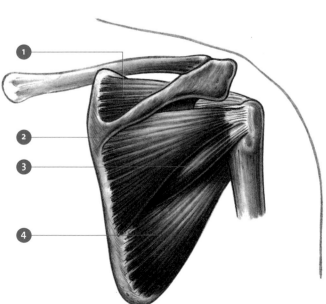

74

The abdomen

The muscles of the abdomen

Powerful muscles of the abdominal wall create movements of the trunk and provide a secure enclosure for the internal organs. The two large, straplike rectus abdominis muscles arise from the costal cartilages of the lower ribs and run down the front of the abdomen to the pubis. These muscles draw the chest and pubis toward each other, causing the trunk to bend forward. On either side of the rectus abdominis muscles are broad sheets of muscles that form the lateral walls of the abdomen. These sheets are arranged in three layers: the innermost is the transversus abdominis, the outermost is the external oblique, and the internal oblique lies in between.

a KEY TO THE ABDOMINAL
MUSCLES: VENTRAL VIEW
1 Rectus abdominis
2 External oblique

b KEY TO THE ABDOMINAL
MUSCLES: LATERAL VIEW
1 Rectus abdominis
2 External oblique
3 Latissimus dorsi

c KEY TO THE OBLIQUE
MUSCLES: LATERAL VIEW
1 Internal oblique

d KEY TO THE OBLIQUE
MUSCLES: LATERAL VIEW
1 Transversus abdominis
2 Sectioned rectus muscles

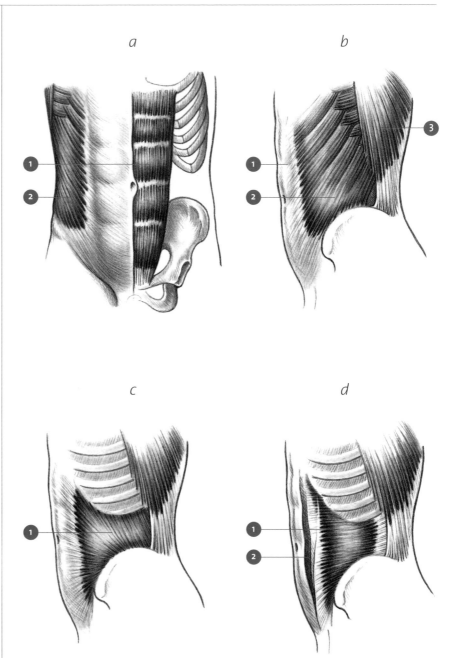

a

b

c

d

How to draw the abdomen

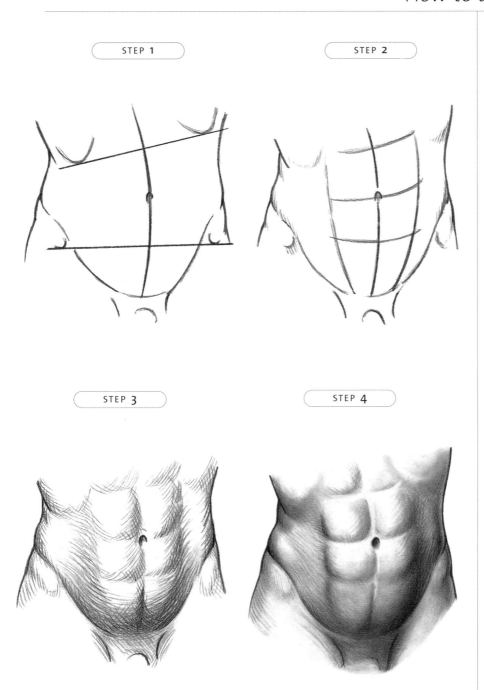

STEP 1

STEP 2

STEP 3

STEP 4

As with the back, there is a convenient central line on the abdomen, the linea alba, which is seen as a slight indentation between the two straps of the rectus abdominis muscle. The umbilicus comes at a point midway between the xiphoid process of the sternum and the arch of the pubic bone.

STEP 1
Figuring out the proportions.

STEP 2
Sketching in the general position of the muscles.

STEP 3
Filling in light and shade, and adding more definition.

STEP 4
Completion.

The male torso

Drawing the male torso

The central line that you used to draw the abdomen can be extended up to the base of the neck, and the position of the clavicles, lower border of the rib cage, and anterior superior iliac spines drawn in.

STEP 1
Drawing a central line and establishing the general proportions.

STEP 2
Drawing in the position of the rectus abdominis muscle.

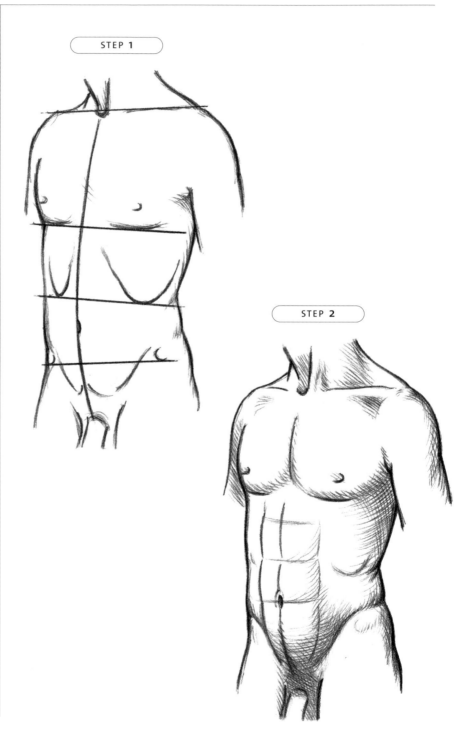

STEP 1

STEP 2

Drawing the male torso

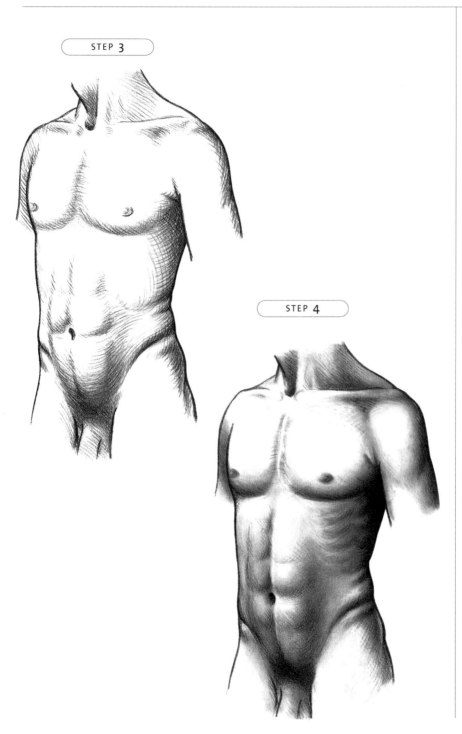

STEP 3

STEP 4

It is useful to remember the three body types that were shown in the introduction. This individual is an obvious mesomorph, and as such is slightly easier to draw because of the well-defined muscle groups, absence of body fat, and prominent bony landmarks.

STEP 3
Establishing form, planes, and tone, plus the areas of light and shade.

STEP 4
Completion.

The female torso

Drawing the female torso

In general, the female torso has a narrower rib cage and waist and wider hips than the male equivalent, although not all figures conform to these general characteristics. The greatest distance is at the hip joints, between the great trochanters of the femoral heads.

STEP 1
Draw in the central line and note the angles of the rib cage and iliac spines as before.

STEP 2
Draw in the position of the breasts and nipples, noting how the breasts move as the arms are raised.

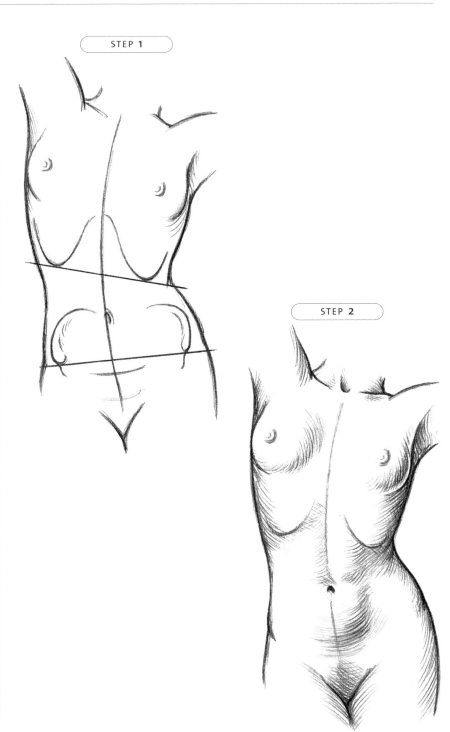

STEP 1

STEP 2

Drawing the female torso

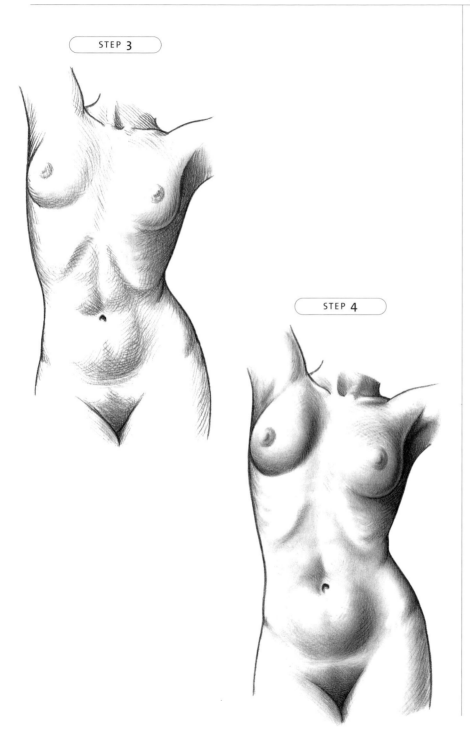

STEP 3

STEP 4

This figure is a similar type to the one drawn on page 77, in order to show the landmarks more clearly. Women tend to have more body fat than men, and as a result these landmarks may not be so well defined. This can make them more challenging to draw, but also more interesting, especially if the models are older.

STEP 3
Start to fill in the areas of tone, taking note of the direction of the light and how this falls on the rib cage and abdomen.

STEP 4
Completion. As with the other drawings, this could be finished at Step 3.

THE UPPER EXTREMITY

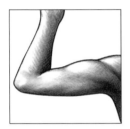 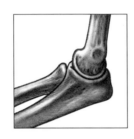 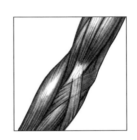 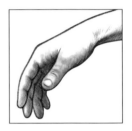

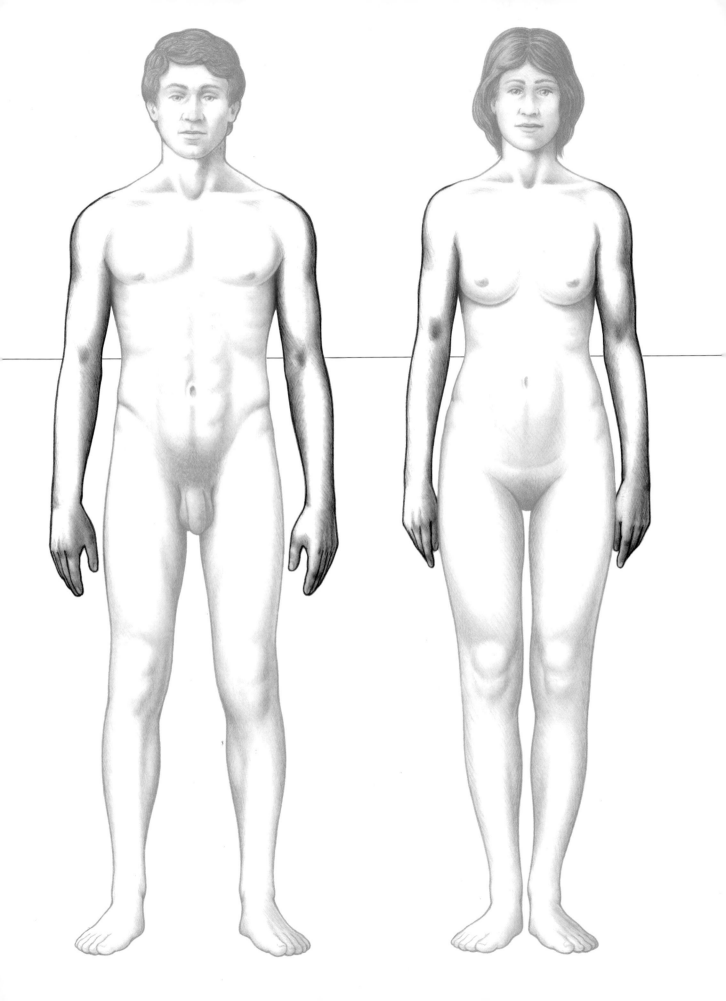

The Upper Extremity

The upper extremity is a structure of striking sophistication and versatility, able to produce movements that range from sweeping, forceful actions to the delicate manipulation of fine objects. Anatomists divide the upper extremity into several parts: the shoulder, upper arm, forearm, and the wrist, hand, and fingers. The first of these, the shoulder, consists of the robust attachment of the upper extremity to the trunk. Here the scapula (shoulder blade) and clavicle (collarbone) form a flexible support for the upper end of the humerus, which is the long, solid bone of the upper arm. Numerous muscles wrap around the skeleton of the shoulder, holding the head of the humerus in position and allowing the upper arm to make a wide range of movements. The deltoid is the most distinctive of these muscles, with its smooth bulk clearly visible beneath the skin of the shoulder.

The arm bending at the elbow

The upper arm consists of long, powerful muscles that run along the shaft of the humerus. These muscles are responsible for the movements of the arm at the elbow: biceps brachii, the rounded contour of which can be seen along the front of the forearm, bends the arm at the elbow, while its counterpart, triceps brachii, straightens it.

Delicate movement: hand and fingers when picking up a small object

Strong movement: hand and arm when gripping a larger object

In contrast to the relative simplicity of the anatomy of the upper arm, the forearm contains a complex array of muscles that produce the intricate movements of the hand and fingers. Many of these muscles are attached to long tendons (sinews) that convey force through the wrist to the hand and onward to the ends of the fingers. Surrounded by these muscles are the ulna and

Hands and arms
in repose

radius, which are the two long, thin bones that run parallel to each other along the length of the forearm.

The skeleton of the wrist consists of a collection of eight small bones that provide a stable foundation for the palm of the hand, as well as a protective channel through which run nerves, blood vessels, and tendons essential to the complex activity of the hand and fingers. Within the hand, slivers of muscle move the fingers from side to side, and the thumb is able to grip powerfully with the aid of a thick bed of muscle clearly visible at its base. At the far end of the palm, columns of bones separated by joints form the skeleton of the fingers, the delicate movements of which are produced by the tendons that run along their whole length.

Muscle definition
when arm is braced

Drawing tips

- There are several landmarks that should be observed when drawing the arm—the shoulder, elbow, and wrist. These may be more or less obvious, depending on the position and viewpoint of the arm.

- Strong shadows will help with the modeling, especially if you are drawing a muscular forearm in certain positions.

- Since the muscular landmarks on a woman's arm may not be so well defined, you may consider drawing the arm with a few lines only, making a feature of the hands.

Fingers when
slightly curled

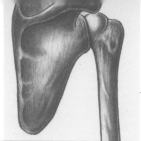

84

The arm

The bones of the arm

The skeleton of the upper arm consists of a single, large bone called the humerus, which extends from the shoulder joint down to the elbow joint. At the elbow, the lower end of the humerus connects to the radius and the ulna, which are the two slender bones of the forearm. A projection of bone called the olecranon is found at the upper end of the ulna, and this can be felt beneath the skin as the distinctive hard point of the elbow. The far end of the radius connects to the carpal bones (the bones of the wrist) to form the wrist joint. Extending from the carpal bones are five metacarpal bones, which run through the palm of the hand. The phalanges are the bones of the digits: the thumb has two phalanges, whereas the other fingers each have three.

a KEY TO THE BONES OF THE
RIGHT ARM: VENTRAL VIEW
1 Scapula
2 Humerus
3 Radius
4 Ulna
5 Carpal bones
6 Metacarpals
7 Phalanges

b KEY TO THE BONES OF THE
LEFT ARM: LATERAL VIEW
1 Acromion
2 Coracoid process
3 Humerus
4 Radius
5 Scapula
6 Olecranon
7 Ulna
8 Carpal bones
9 Metacarpals
10 Phalanges

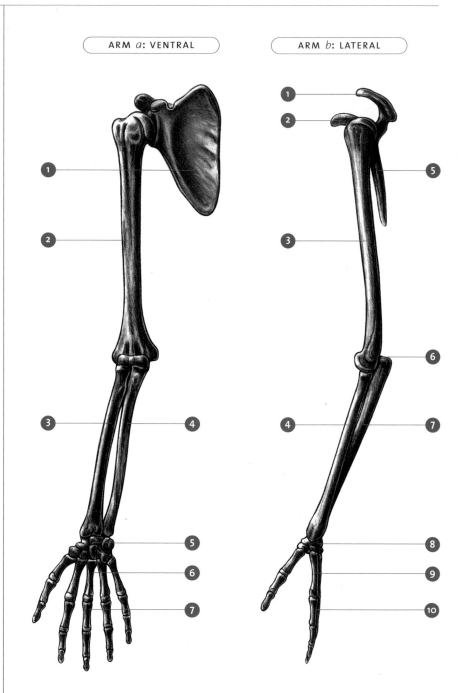

ARM *a*: VENTRAL

ARM *b*: LATERAL

The bones of the arm

ARM : DORSAL

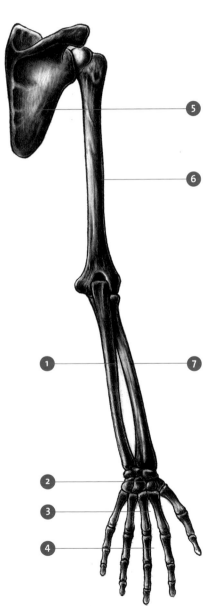

The radius is able to rotate because its upper end is disk-shaped. As it does so, it carries the wrist with it: this causes the hand to turn, as in twisting a doorknob. Turning the forearm so that the palm faces upward or forward is supination. In supination the ulna and radius run parallel to each other, but in pronation the radius twists around the ulna, so that the two bones cross over one another. The ulna is unable to rotate, because its upper end forms a stable hingelike joint at the elbow, allowing the arm to bend easily yet support heavy weights.

In pronation, the forearm and wrist rotate so that the palm faces downward or backward. During this action the radius twists around the ulna, so that the two bones cross over each other.

KEY TO THE BONES OF THE ARM: DORSAL VIEW
1 Ulna
2 Carpal bones
3 Metacarpals
4 Phalanges
5 Scapula
6 Humerus
7 Radius

86

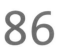

The arm

The muscles of the arm

The intricate musculature of the upper limb permits powerful movements of the arm, as well as subtle movements of the fingers. Bulky muscles such as deltoid and pectoralis major connect the humerus to the axial skeleton and produce movement of the arm at the shoulder, while triceps, biceps, and brachialis run along the length of the humerus and bend and straighten the arm at the elbow. Fine slivers of muscle in the forearm transmit their force to the hand via long tendons.

a KEY TO THE ARM MUSCLES:
VENTRAL
1 Pectoralis major
2 Deltoid
3 Lateral head of triceps
4 Biceps
5 Medial head of triceps
6 Brachioradialis
7 Pronator teres
8 Flexor carpi radialis
9 Palmaris longus
10 Flexor carpi ulnaris

b KEY TO THE ARM MUSCLES:
LATERAL
1 Deltoid
2 Triceps
3 Biceps
4 Brachioradialis
5 Extensor carpi radialis
 longus

c KEY TO THE ARM MUSCLES:
DORSAL
1 Deltoid
2 Triceps (Long head)
3 Triceps (Lateral head)
4 Flexor carpi ulnaris
5 Extensor carpi ulnaris
6 Extensor digitorum

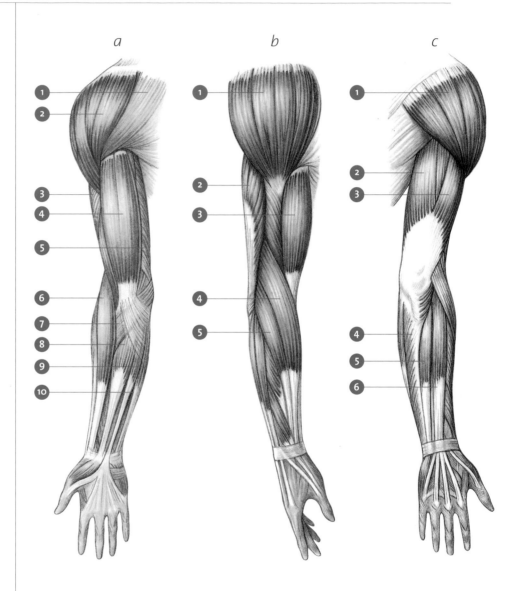

a

b

c

The muscles of the arm

In addition to bending and straightening the upper limb, several muscles rotate the forearm and wrist, bringing the movements of pronation and supination. These muscles include biceps, brachioradialis, and pronator teres. The axilla is given its shape by muscles of the rib cage, scapula, and humerus, such as latissimus dorsi, pectoralis major, and biceps.

a KEY TO FOREARM IN PRONATION: VENTRAL VIEW
1 Biceps
2 Pronator teres
3 Brachioradialis

b FOREARM IN PRONATION: DORSAL VIEW

c KEY TO AXILLA (ARMPIT)
1 Brachialis
2 Biceps
3 Triceps
4 Pectoralis major
5 Coracobrachialis
6 Teres major
7 Latissimus dorsi

88

The arm

Drawing the arm

The most obvious landmarks in this example are the acromio-clavicular joint of the shoulder, the lateral epicondyle of the humerus, and the distal head of the ulna at the wrist.

STEP 1
The distance from the shoulder to the elbow is the same as the distance from the elbow to the knuckles. (This arm is slightly foreshortened.) The arm can be seen as two tubes in perspective.

STEP 2
Drawing in the position of the arm muscles. NOTE: the muscles may be more or less obvious depending on the age, sex, or body type of the subject.

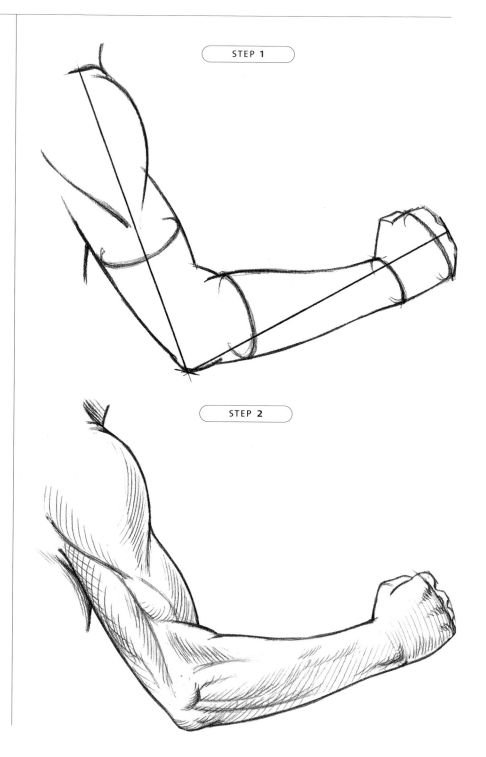

STEP 1

STEP 2

Drawing the arm

This is the kind of drawing that would work well on a large sheet of paper, when you can emphasize the muscular appearance of the arm with strong lines and bold strokes for the rendering.

STEP 3
Working up the form of the muscles in the arm.

STEP 4
Completion.

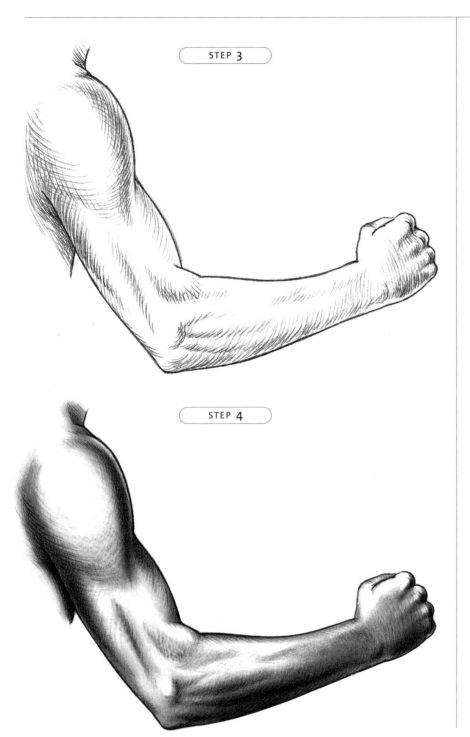

STEP 3

STEP 4

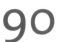

90

The scapula (shoulder blade)

The scapula

The scapula consists of a triangular plate of bone that lies against the posterior surface of the upper rib cage. It is held in place by muscles that alter its position in order to bring about movements of the shoulder. A ridge of bone called the spine runs along the posterior surface of the scapula. At the upper end of the spine is the acromion, to which the end of the clavicle is attached. The glenoid cavity is a cup-shaped recess in the outer corner of the scapula, which accommodates the head of the humerus in order to form the shoulder joint.

a KEY TO RIGHT SCAPULA:
ANTERIOR SURFACE
1 Acromion
2 Coracoid process
3 Glenoid cavity
4 Lateral border
5 Superior border
6 Medial border

b KEY TO LEFT SCAPULA:
LATERAL SURFACE
1 Acromion
2 Coracoid process
3 Glenoid cavity
4 Lateral border

c KEY TO RIGHT SCAPULA:
POSTERIOR SURFACE
1 Supraspinous fossa
2 Spine
3 Infraspinous fossa
4 Acromion

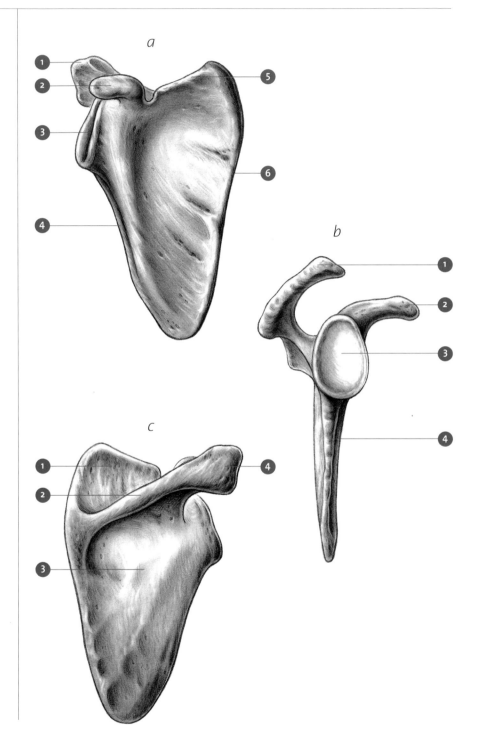

The scapula

The lateral end of the clavicle meets the acromion at the acromioclavicular joint. The joint is supported by tough ligaments that run between the coracoid process and the clavicle, which hold the clavicle firmly in place in order to prevent it from becoming dislocated. Several muscles arise from the scapula: for example, the portions of the biceps and triceps muscles originate from just above and below the glenoid cavity,

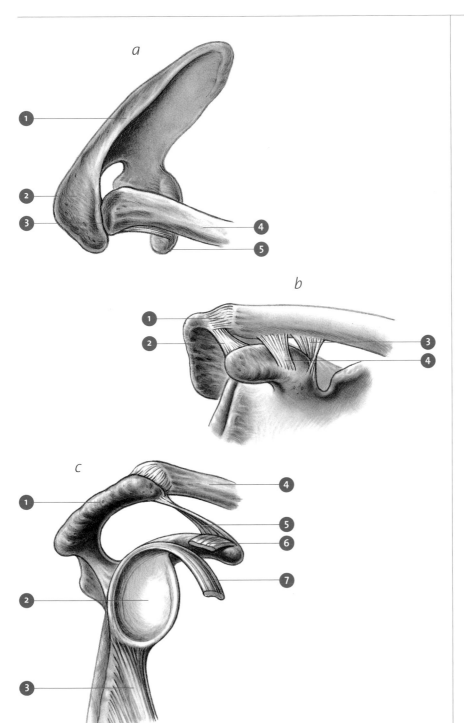

a KEY TO THE RIGHT SCAPULA:
VIEW FROM ABOVE
1 Spine
2 Acromion
3 Acromioclavicular joint
4 Clavicle
5 Coracoid process

b KEY TO THE SHOULDER
LIGAMENTS
1 Acromioclavicular ligament
2 Coracoacromial ligament
3 Conoid coracoacromial ligament
4 Trapezoid coracoclavicular ligament

c KEY TO THE SHOULDER
(DETAIL)
1 Acromion
2 Glenoid cavity
3 Long head of triceps
4 Clavicle
5 Coracoacromial ligament
6 Coracohumeral ligament
7 Long head of biceps tendon

92

The humerus

The skeleton and muscles of the upper arm

The skeleton of the upper arm consists of the humerus, which is a long, sturdy bone that extends from the shoulder joint to the elbow. The head (upper end) of the humerus is rounded, and rests in the cuplike glenoid cavity of the scapula, which allows the arm to move freely at the shoulder. At the lower end of the humerus, barrel-shaped areas of bone called the trochlea and capitulum form hingelike joints with the ulna and radius. Biceps and brachialis are muscles that run along the ventral surface of the humerus, and serve to bend the arm at the elbow.

a KEY TO THE BONES OF
THE ARM
1 Humerus
2 Radius
3 Ulna

b KEY TO THE HUMERUS BONE:
VENTRAL VIEW
1 Greater tubercle
2 Intertubercular groove
3 Anterior surface
4 Lateral supracondylar ridge
5 Radial fossa
6 Capitulum
7 Head
8 Lesser tubercle
9 Surgical neck
10 Medial supracondylar ridge
11 Coronoid fossa
12 Trochlea

c KEY TO THE HUMERUS
MUSCLE: VENTRAL VIEW
1 Biceps
2 Brachialis

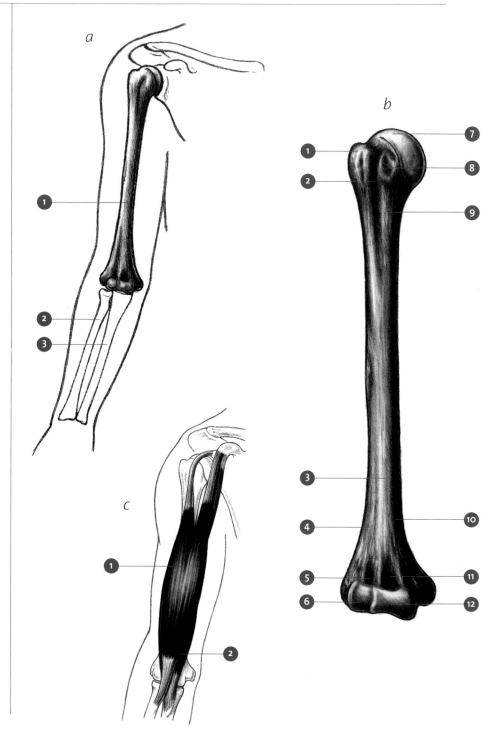

The skeleton of the upper arm

A rough elevation called the deltoid tuberosity can be seen on the lateral surface of the shaft of the humerus. This provides a point of attachment for the deltoid muscle, which arises from the lateral part of the clavicle, the spine of the scapula, and the acromion. The deltoid muscle bends, straightens, and rotates the arm at the shoulder joint, and also raises the arm outward from the side of the body.

a **KEY TO THE HUMERUS BONE: LATERAL VIEW**
1 Head
2 Anatomical neck
3 Lateral epicondyle
4 Greater tubercle
5 Lateral lip of intertubercular groove
6 Deltoid tuberosity
7 Anterior surface
8 Lateral edge of capitulum

b **KEY TO THE DELTOID MUSCLE: LATERAL VIEW**
1 Spine
2 Acromion process
3 Clavicle
4 Deltoid muscle
5 Humerus

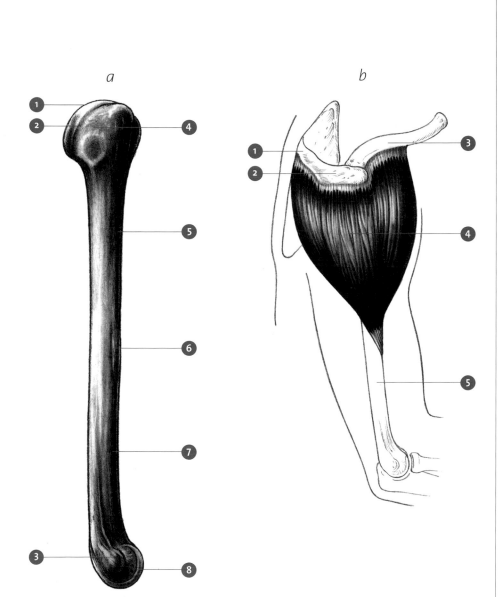

a

b

The skeleton and muscles of the upper arm

The dorsal surface of the humerus has several distinguishing features. The radial nerve (one of the major nerves of the arm) winds around the humerus, and a groove along the shaft of the bone marks its path. At the lower end of the humerus, an indentation called the olecranon fossa accommodates the olecranon (a projection of bone at the upper end of the ulna) where the arm is held straight. The triceps muscle runs along the dorsal surface of the humerus and consists of three parts: the long head, the lateral head, and the medial head (which is buried beneath the lateral and long heads). Triceps straightens the arm at the elbow.

a KEY TO THE HUMERUS
BONE: DORSAL VIEW
1 Head
2 Greater tubercle
3 Surgical neck
4 Groove for radial nerve
5 Olecranon fossa
6 Medial epicondyle
7 Trochlea
8 Lateral epicondyle

b KEY TO THE HUMERUS
BONE: MEDIAL VIEW
1 Head
2 Lesser tubercle
3 Surgical neck
4 Medial epicondyle
5 Medial surface of trochlea

c KEY TO THE TRICEPS
MUSCLE: DORSAL VIEW
1 Lateral head
2 Long head
3 Olecranon

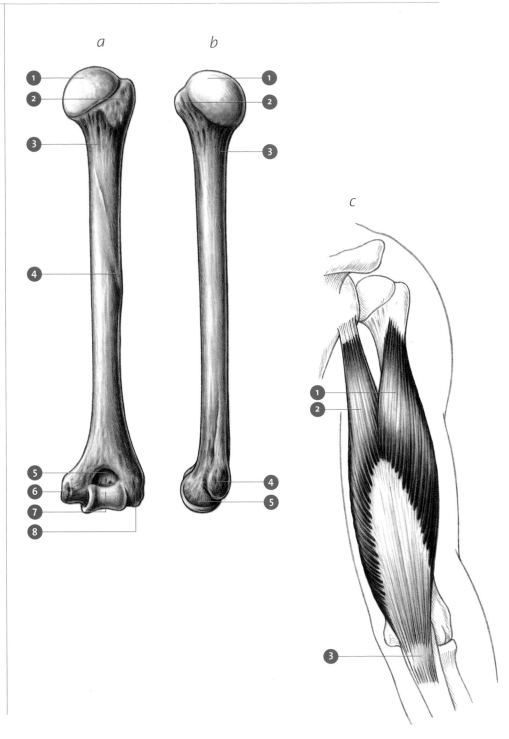

The bones of the elbow joint

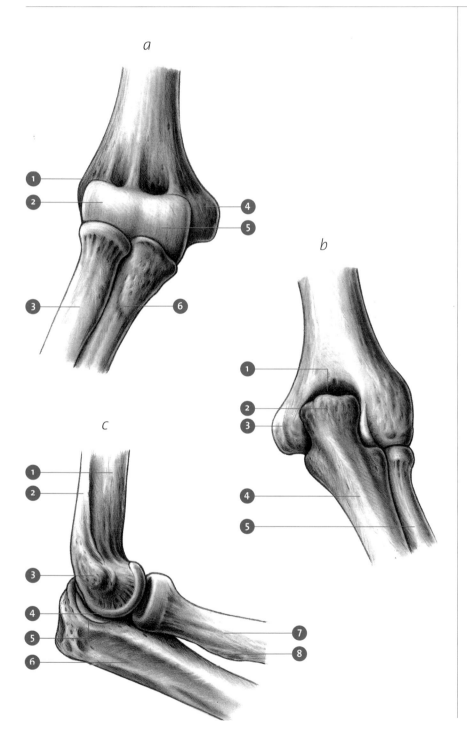

At the elbow joint, the trochlea articulates with the trochlear notch of the ulna, and the capitulum with the disklike head of the radius. The joint resembles a hinge: its range of movement is limited to allowing the arm to bend and straighten. When the elbow is straight, the olecranon rests in the olecranon fossa at the lower end of the humerus. In any position of the elbow, the head of the radius is able to rotate against the capitulum, so that the forearm and wrist can twist.

a KEY TO THE RIGHT ELBOW JOINT: ANTERIOR VIEW
1 Lateral epicondyle
2 Capitulum
3 Radius
4 Medial epicondyle
5 Trochlea
6 Ulna

b KEY TO THE ELBOW JOINT: POSTERIOR VIEW
1 Olecranon fossa
2 Olecranon
3 Medial epicondyle
4 Ulna
5 Radius

c KEY TO THE ELBOW JOINT: LATERAL VIEW
1 Humerus
2 Lateral supracondylar ridge
3 Lateral epicondyle
4 Capitulum
5 Trochlea notch
6 Ulna
7 Radius
8 Radial tuberosity

96

The radius

The skeleton of the forearm

The upper end of the radius is disk-shaped, enabling the bone to rotate. In contrast, the lower end of the radius is firmly attached to the skeleton of the wrist, so that when the radius rotates, the wrist and hand move with it. The radius and ulna meet at their upper and lower ends, and a groove called the ulnar notch allows the radius to rotate freely around the ulna. The radius and ulna are connected by a sheet of fibrous tissue called the interosseus membrane, which extends across the gap between the two bones.

a **KEY TO THE BONES OF THE ARM**
1 Clavicle
2 Scapula
3 Humerus
4 Radius
5 Ulna

b **KEY TO THE RADIUS: ANTERIOR VIEW**
1 Head
2 Neck
3 Anterior oblique line
4 Anterior surface
5 Styloid process
6 Radial tuberosity
7 Interosseous border
8 Ulnar notch

c **KEY TO THE RADIUS AND ULNA: CROSS-SECTIONAL VIEW**
1 Interosseous membrane
2 Radius
3 Ulna

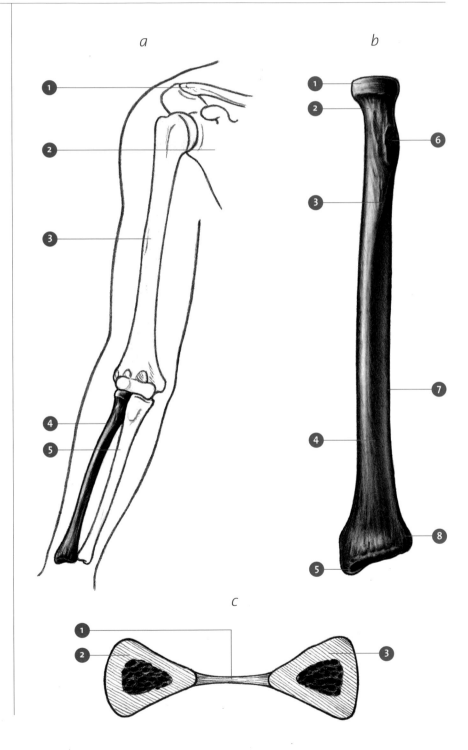

The skeleton of the forearm

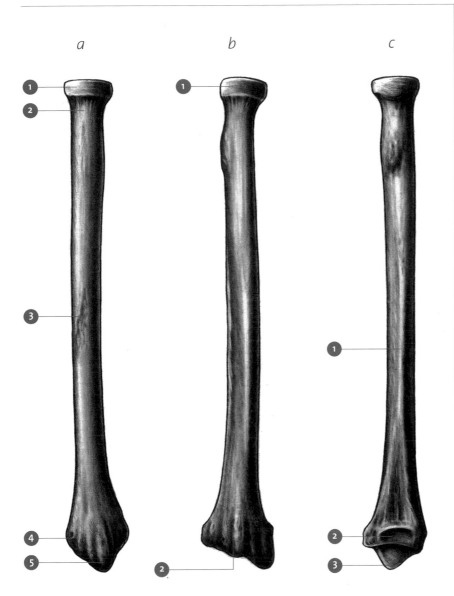

a *b* *c*

Surface features along the length of the radius allow muscles to connect to the bone: for example, biceps attaches to the radial tuberosity, while the pronator teres binds to a roughened area farther along the shaft. The lower end of the radius is bulkier than the rest of the bone and is marked by grooves that make way for tendons. At the far end of the radius, the styloid process can be felt beneath the skin as a projection of bone on the side of the wrist nearest the thumb.

a **KEY TO THE RADIUS:**
LATERAL VIEW
1 Head
2 Neck
3 Rough area for pronator teres muscle
4 Dorsal tubercle
5 Styloid process

b **KEY TO THE RADIUS:**
POSTERIOR VIEW
1 Head
2 Dorsal tubercle

c **KEY TO THE RADIUS:**
MEDIAL VIEW
1 Interosseous border
2 Ulnar notch
3 Styloid process

The ulna

The skeleton of the forearm

The ulna is bulky at its upper end and gradually becomes more slender along its length. Projecting from the upper end of the ulna is the olecranon: this contains a cuplike depression called the trochlear notch, into which rests the trochlea of the humerus in order to form the elbow joint. The lower end of the ulna is called the head: makes contact with the ulnar notch of the radius. The shaft of the ulna has three edges (anterior, posterior, and interosseus) and so is approximately triangular in cross section.

a KEY TO THE BONES OF
THE ARM
1 Clavicle
2 Scapula
3 Humerus
4 Radius
5 Ulna

b KEY TO THE ULNA:
VENTRAL VIEW
1 Olecranon
2 Trochlear notch
3 Supinator crest
4 Ulna tuberosity
5 Interosseous border
6 Anterior surface
7 Head
8 Coronoid process
9 Anterior border
10 Styloid process

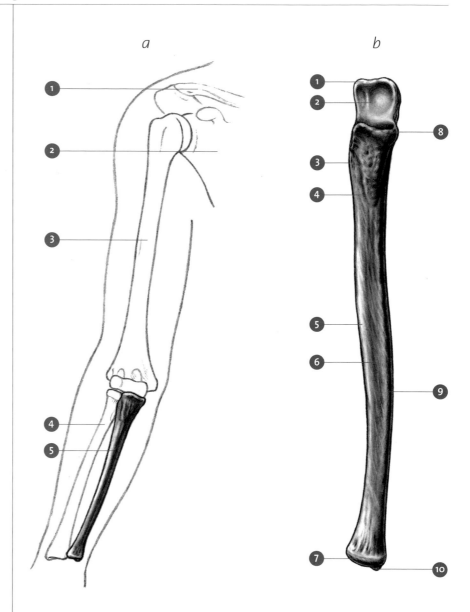

a

b

The skeleton of the forearm

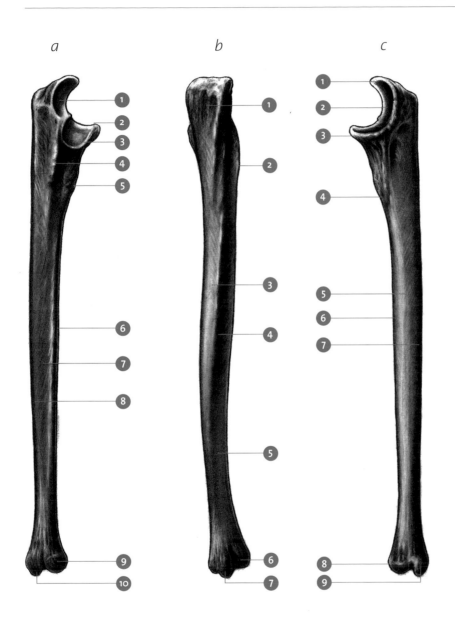

a

b

c

Adjacent to the trochlear notch is the radial notch, which provides a groove in which the disklike head of the radius can rotate. The supinator crest is one of the points from which the supinator muscle arises: as its name suggests, this muscle rotates the radius in order to bring about supination of the forearm and wrist. The head of the ulna articulates with the lower end of the radius, which is a lump at the back of the wrist.

a KEY TO THE ULNA:
LATERAL VIEW
1 Trochlear notch
2 Coronoid process
3 Radial notch
4 Supinator crest
5 Ulnar tuberosity
6 Interosseous border
7 Posterior surface
8 Posterior border
9 Head
10 Styloid process

b KEY TO THE ULNA:
POSTERIOR VIEW
1 Olecranon
2 Supinator crest
3 Medial surface
4 Posterior border
5 Posterior surface
6 Head
7 Styloid process

c KEY TO THE ULNA:
MEDIAL VIEW
1 Olecranon
2 Trochlear notch
3 Coronoid process
4 Ulnar tuberosity
5 Anterior border
6 Anterior surface
7 Posterior border
8 Head
9 Styloid process

The muscles of the lower arm

The forearm contains an intricate array of muscles, many of which send long tendons to the wrist and fingers in order to produce movements of the hand. These muscles are arranged in layers: some are close to the skin, while others lie deeper beneath the surface. In general, muscles on the ventral side of the forearm are responsible for bending the wrist and fingers, for example when grasping an object.

a KEY TO THE SUPERFICIAL MUSCLES OF THE LOWER ARM: VENTRAL VIEW
Superficial muscles seen under the surface of the arm
1 Brachioradialis
2 Flexor carpi radialis
3 Palmaris longus
4 Flexor carpi ulnaris

b KEY TO THE SUPERFICIAL MUSCLE LAYERS OF THE LOWER ARM: VENTRAL VIEW
1 Humerus
2 Radius
3 Ulna
4 Flexor digitorum superficialis
5 Flexor pollicis longus
6 Carpal bones
7 Metacarpal bones

c KEY TO THE DEEP MUSCLE LAYERS OF THE LOWER ARM: VENTRAL VIEW
1 Flexor pollicis longus
2 Flexor digitorum profundis

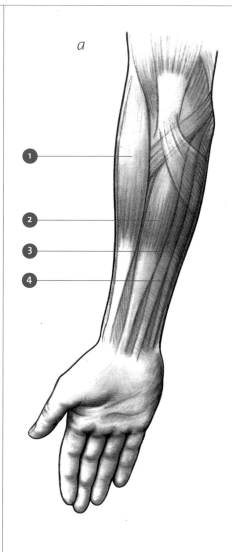

a

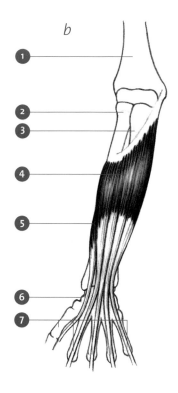

b

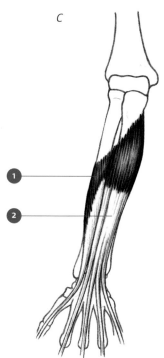

c

The muscles of the lower arm

The muscles of the dorsal side of the forearm are mainly responsible for straightening the wrist and fingers. As on the ventral side, many of these muscles transmit their force through long tendons that extend from the forearm down to the hand. Deep beneath the dorsal surface of the upper forearm are anconeus and supinator, which are muscles that contribute to straightening and rotation of the forearm.

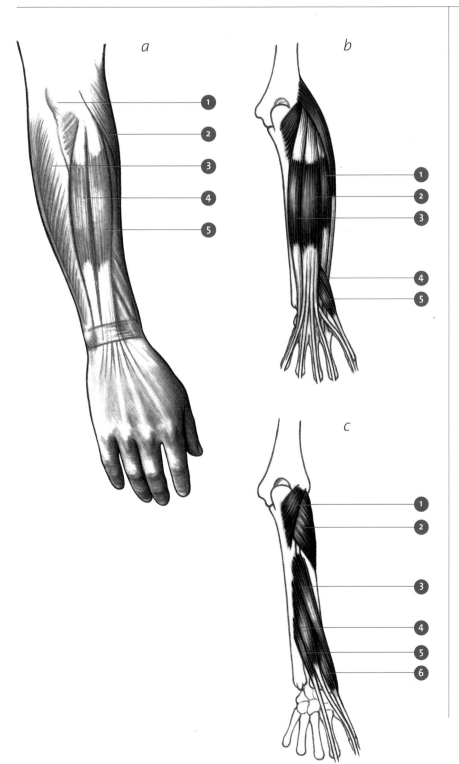

a KEY TO THE SUPERFICIAL
MUSCLES OF THE LOWER ARM:
DORSAL VIEW
1 Olecranon
2 Brachioradialis
3 Flexor carpi ulnaris
4 Extensor carpi ulnaris
5 Extensor digitorum

b KEY TO THE DEEP
MUSCLES OF THE LOWER ARM:
DORSAL VIEW
1 Extensor carpi radialis longus
2 Extensor digitorum
3 Extensor carpi ulnaris
4 Abductor pollicis longus
5 Extensor pollicis brevis

c KEY TO THE DEEP
MUSCLES OF THE LOWER ARM:
DORSAL VIEW
1 Anconeus
2 Supinator
3 Abductor pollicis longus
4 Extensor pollicis longus
5 Extensor indicis
6 Extensor pollicis brevis

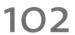
The hand

The carpal bones

The skeleton of the wrist consists of a cluster of eight small bones called the carpal bones. The lower end of the radius articulates with several of the carpal bones, forming the wrist joint. At the far end of the wrist, the carpal bones meet the metacarpal bones (the bones of the palm).

a KEY TO THE CARPAL
BONES OF THE RIGHT HAND:
DORSAL VIEW
1 Pisiform
2 Triquetral
3 Hamate
4 Capitate
5 Metacarpal bones
6 Lunate
7 Scaphoid
8 Trapezoid
9 Trapezium

b KEY TO THE CARPAL
BONES OF THE RIGHT HAND:
PALMAR VIEW
1 Scaphoid
2 Trapezium
3 Trapezoid
4 Lunate
5 Triquetral
6 Pisiform
7 Capitate
8 Hamate

c KEY TO THE CARPAL
BONES OF THE RIGHT HAND:
MEDIAL VIEW
1 Scaphoid
2 Trapezoid
3 Trapezium

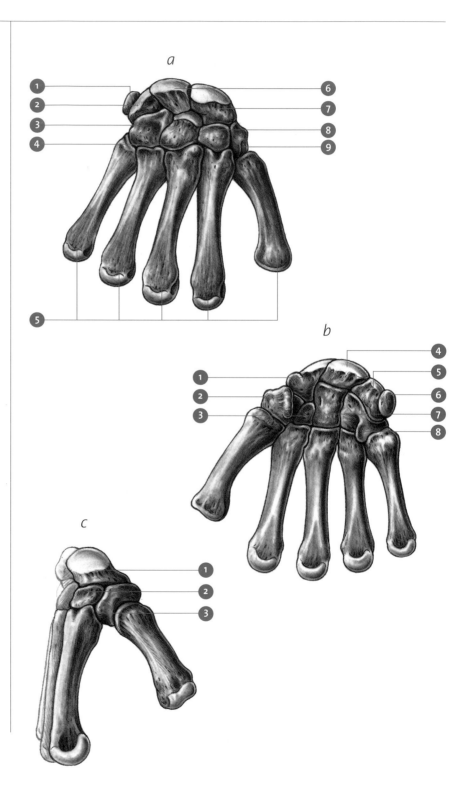

The ligaments of the wrist

Many ligaments surround the carpal bones, binding them to each other and to the metacarpal bones, the radius, and the ulna. In cross section, the carpal bones form an archlike shape: this is called the carpal tunnel and it protects the nerves within.

a KEY TO THE LIGAMENTS OF THE WRIST: DORSAL VIEW
1. Radius
2. Ulna
3. Ulna collateral ligament
4. Dorsal metacarpal ligaments
5. Dorsal radiocarpal ligament
6. Dorsal intercarpal ligaments
7. Metacarpal bone of thumb

b KEY TO THE LIGAMENTS OF THE WRIST: PALMAR VIEW
1. Palmar radiocarpal ligament
2. Radial collateral ligament
3. Flexor retinaculum
4. Metacarpal bone of thumb
5. Palmar metacarpal ligaments
6. Hook of hamate bone
7. Pisometacarpal ligament
8. Pisiform bone
9. Radial collateral ligament

c KEY TO THE LIGAMENTS OF THE WRIST: CROSS SECTION
1. Trapezoid bone
2. Trapezium bone
3. Median nerve
4. Capitate bone
5. Hamate bone
6. Tendons
7. Flexor retinaculum

104

The hand

The skeleton of the hand

The skeleton of the hand consists of the metacarpal bones, which are the bones of the palm, and the phalanges, which are the bones of the fingers. The metacarpals form joints with the carpal bones at one end, and at the other end they articulate with the proximal (near) phalanges at the metacarpophalangeal joints. The phalanges are held together by the interphalangeal joints, which allow the fingers to bend when gripping an object.

a **KEY TO THE BONES OF THE HAND: DORSAL VIEW**
1 Carpal bones
2 Metacarpal bones
3 Phalanges

b **KEY TO THE THIRD FINGER: SHOWING JOINT CAPSULES**
1 Metacarpal
2 Phalanges
3 Metacarpophalangeal joint
4 Proximal interphalangeal joint
5 Distal interphalangeal joint

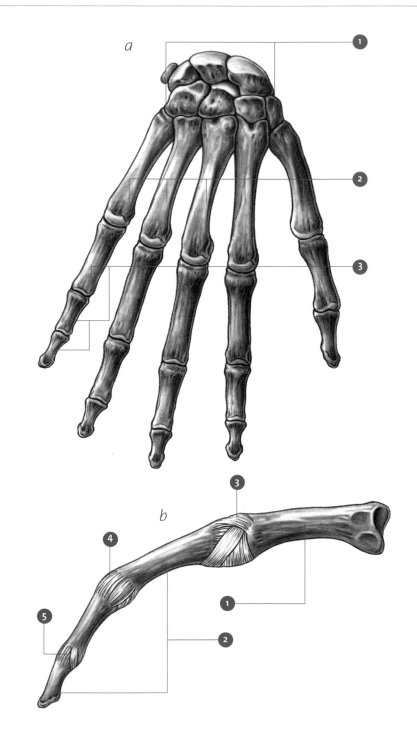

The skeleton of the hand

The thumb has two phalanges, which are referred to as the proximal (near) and distal (far) phalanges. The remaining fingers each have three phalanges, which are the proximal, middle, and distal phalanges.

a KEY TO THE BONES OF THE HAND: PALMAR VIEW
1 Carpals
2 Metacarpals
3 Phalanges

b THE BONES OF THE HAND: MEDIAL VIEW
1 Carpal bones
2 Metacarpal bones
3 Proximal phalanges
4 Middle phalanx
5 Distal phalanges

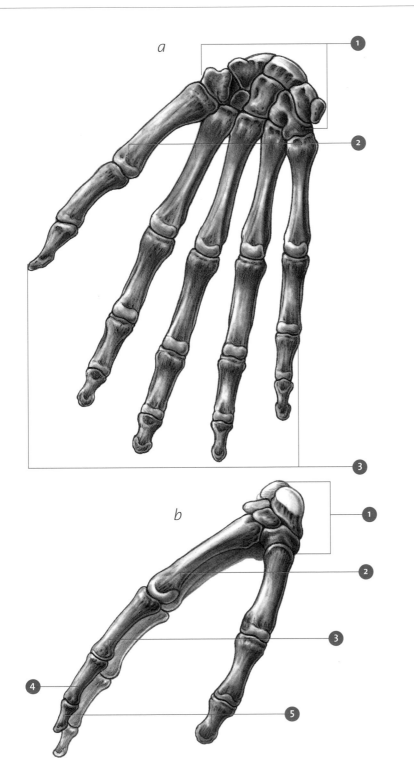

106

The muscles of the hand

Movements of the hand are brought about by muscles of the forearm, which exert their effect via long tendons, and by much smaller muscles located within the hand itself, known as intrinsic muscles. In general, the forearm muscles are responsible for simple, powerful hand movements, whereas delicate tasks are carried out by the numerous intrinsic hand muscles. The intrinsic muscles consist of three groups: two form the fleshy mounds found at the base of the thumb and little fingers (known as the thenar and hypothenar eminences), and the third consists of the interossei and lumbricals.

a **KEY TO THE MUSCLES OF THE HAND**
1 Opponens pollicis
2 Abductor pollicis brevis
3 Flexor pollicis brevis
4 Adductor pollicis
5 Pisiform
6 Abductor digiti minimi
7 Flexor digiti minimi
8 Opponens digiti minimi
9 Lumbricals
10 Split tendon of flexor digitorum superficialis
11 Tendon of flexor digitorum profundis

b **KEY TO THE MUSCLES OF THE HAND**
1 Opponens pollicis
2 Adductor pollicis
3 Opponeis digiti minimi

c
To show the flexion of the thumb, which is brought about by flexor pollicis longus and brevis.

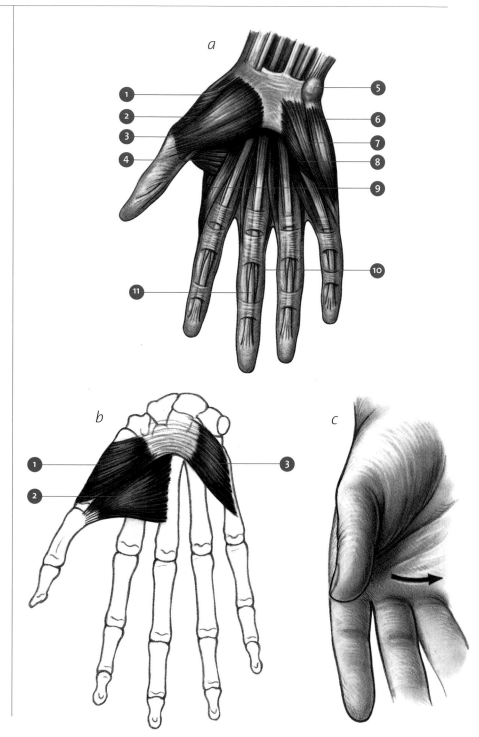

The muscles of the hand

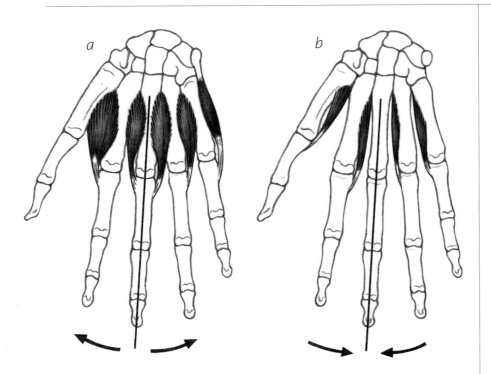

The interossei are fine slips of muscle that run along the metacarpal bones. The dorsal interossei are responsible for spreading the index, middle, and ring fingers away from an imaginary line running through the center of the middle finger: this is abduction of the fingers. The little finger and thumb have their own abductor muscles, so are not acted upon by the dorsal interossei. Because it is not possible for the middle finger to be drawn toward itself, palmar interossei are found in all but the middle finger.

a ABDUCTION
Dorsal interossei
This shows the abductor digiti minimi, which abducts the little finger. Abduction of the fingers involves spreading the fingers away from an imaginary line running down the center of the middle finger.

b ADDUCTION
Palmar interossei
Adduction of the fingers involves drawing the fingers toward an imaginary line running down the center of the middle finger.

c
This shows the extension of the index finger and the flexion of the other fingers. The fingers are also held together (i.e. in adduction) by the palmar interossei.

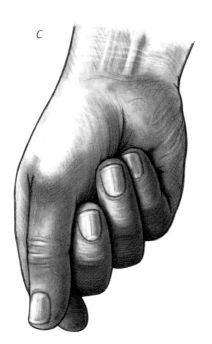

108

How to draw hands

Drawing hands at rest

Hands can have as much character as a face, and may give an indication of the type of work a person does or his or her lifestyle. When compared with the female hand, the main features of the male hand are its greater angularity, obvious surface texture, and bony projections.

STEP 1
NOTE: the rectangular section of the fingers and the relative absence of curves. Always compare the size of the hand with the face—there is a tendency to make the hand too small.

STEP 2
Position the fingernails in relation to the fingertips— this is a good indication of the amount of foreshortening that is needed.

STEP 3
Detail the planes and position of joints in relation to each other.

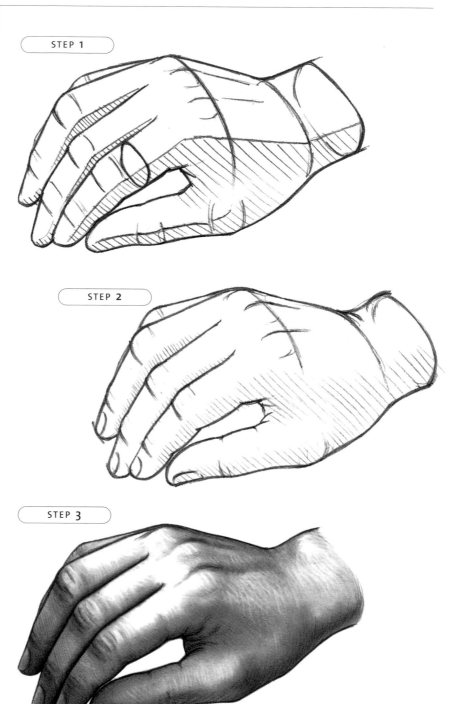

STEP 1

STEP 2

STEP 3

Drawing female hands at rest

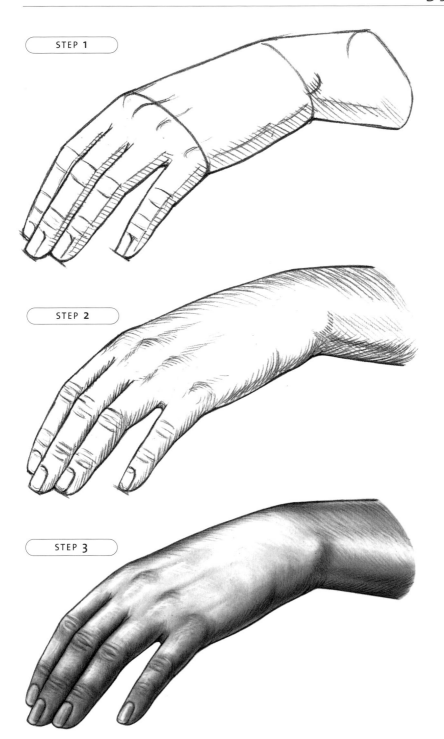

STEP 1

STEP 2

STEP 3

The female hand usually has a finer, more delicate bone structure, and the overall effect is one of elongation, with tapering fingers and oval nails. Female hand gestures generally have more refinement of posture and movement. With the wrist in the position shown, the fingers have a tendency to extend and slaighten themselves.

STEP 1
Notice the slightly longer shapes when starting to draw the basic proportions, also the plane changes at the wrist, back of the hand, and fingers.

STEP 2
Establish the tones, noting the direction of light and the relative position of the joints as on page 108. Observe in particular the position of the carpometacarpal joints in relation to the point at which the fingers join the hand.

STEP 3
The completed drawing.

110

How to draw hands

Drawing movement in hands

This is a drawing of the hand when pushing with the fingers against a wall. You could try sketching your own hand in this position, looking at the appearance of the extensor tendons of the fingers and thumb, as shown here.

STEP 1
Figure out the relative distances between the ends of the fingers, the back of the hand, and the wrist, and the position of the thumb in relation to the index finger.

STEP 2
Develop the details and tones, looking at the way the fingernails appear in perspective.

STEP 3
Completion, with rendering of the tendons and creases at the finger joints.

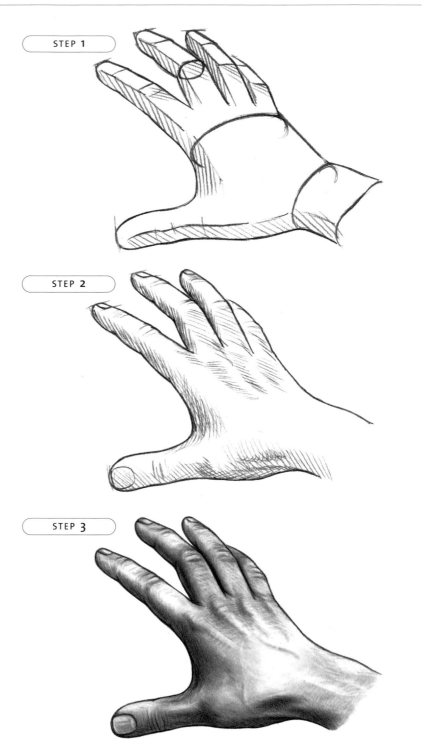

Drawing movement in hands

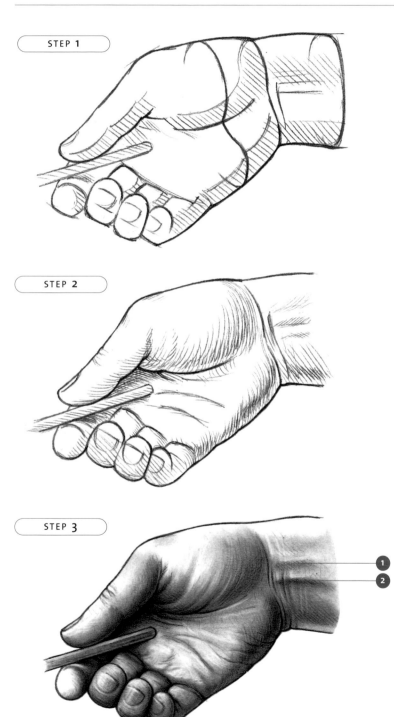

STEP 1

STEP 2

STEP 3

This drawing of a hand holding a pencil loosely between the thumb and index finger is similar to the position that you might use when doing quick sketches with charcoal. Notice how cushioned and fleshy the palm and fingers appear compared with the back of the hand.

STEP 1
Observe the angle of the hand and the contour lines on the wrist, palm, and fleshy part of the thumb.

STEP 2
Start working on the areas of light and tone, noting that the darkest area here is under the thumb and pencil.

STEP 3
The drawing completed, with details on the palm and on the wrist.

KEY TO THE TENDONS OF THE WRIST
1 Flexor carpi radialis
2 Palmaris longus

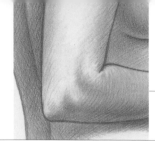

How to draw arms

Drawing arms at rest

This is a view of the arm resting on a table, with the light source coming from the left-hand side of the figure. The point to watch here is the foreshortening of the upper arm, which can be shown more faintly, with the forearm drawn with stronger lines to emphasize a feeling of depth.

STEP 1
Get the proportions looking right—it may help to think of the arm as two cylinders in perspective.

STEP 2
Build up the tones and muscle forms.

STEP 3
Complete by softening the lines of the upper arm using a putty eraser.

**KEY TO THE MUSCLES
OF THE FOREARM**
1 Position of abductor pollicis longus
2 Extensor carpi radialis brevis
3 Extensor digitorum
4 Extensor carpi ulnaris
5 Extensor carpi radialis longus

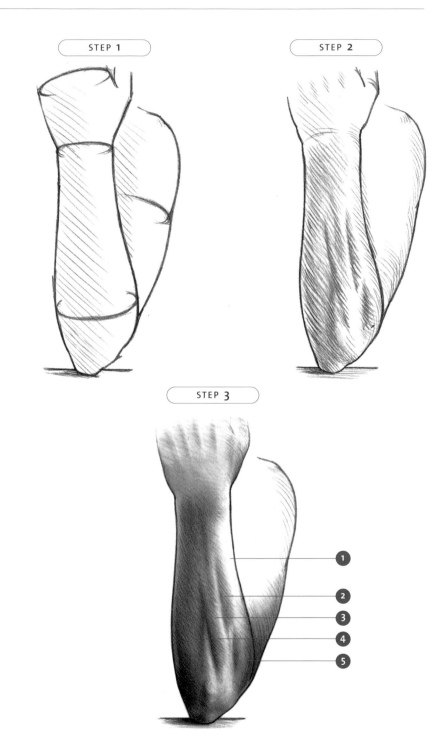

Drawing the torso

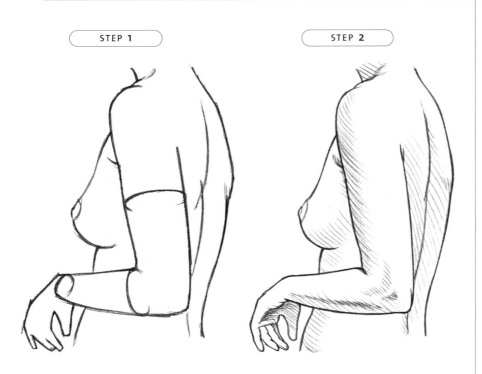

STEP 1

STEP 2

STEP 3

This view was chosen because of the angularity of the arm compared to the soft roundness of the breast, and the way that the line of the upper arm comes across the curve of the spine.

STEP 1
Note the distance from the shoulder to the elbow to the knuckles.

STEP 2
The planes and perspective of the upper and lower arm.

STEP 3
The relationship of the arm to the trunk and neck.

KEY TO THE ARMS AND THE TRUNK
1 Deltoid
2 Extensor carpi radialis longus
3 Lateral epicondyle of humerus
4 Olecranon

THE LOWER EXTREMITY

 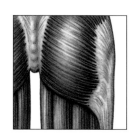 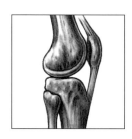 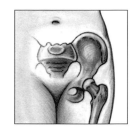

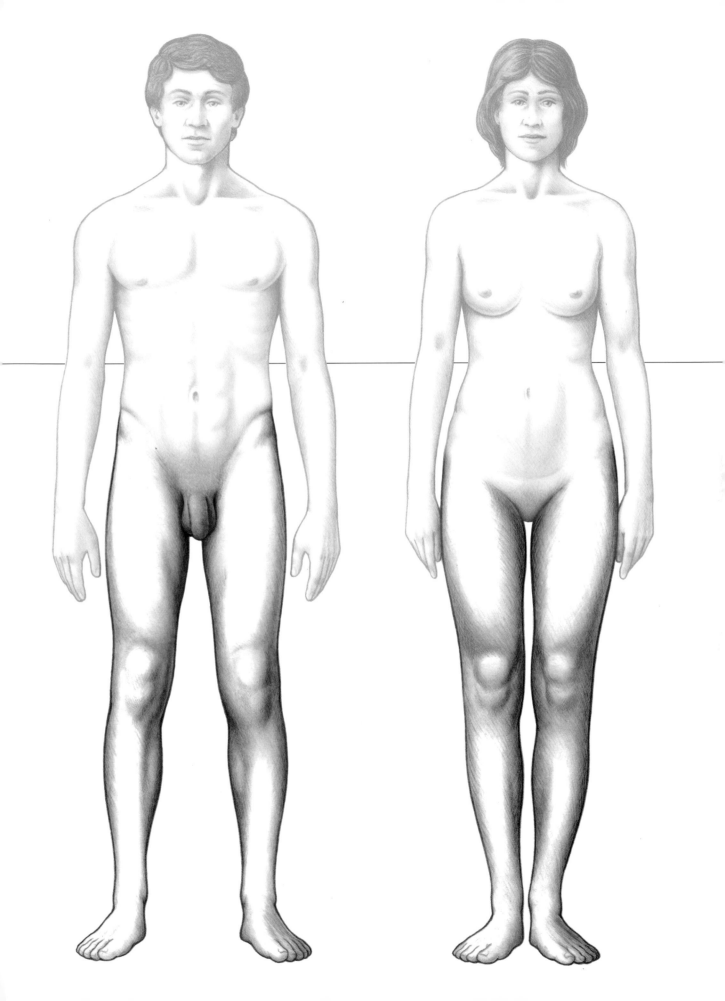

The lower extremity

The lower extremity is a robust and complex part of the body that combines powerful movement with the resilience required to absorb the forces generated during walking and running. It meets the trunk at the hip, where a secure yet versatile joint is formed by the insertion of the rounded upper end of the femur (thighbone) into a socketlike indentation on the side of the pelvis. This joint provides a stable anchoring point for the lower extremity but also allows the leg to bend and rotate freely in response to contractions of muscles in the pelvis, buttock, and thigh.

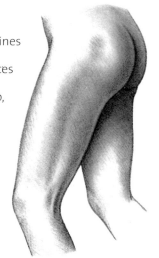

Male leg and torso

The femur is the longest and strongest bone of the body and extends from the hip to the knee. Surrounding the femur is an impressive mass of muscles that forms the thigh: those at the front of the thigh straighten the knee, those at the back bend the knee, and those that run along the inner thigh draw the limb in toward the opposite leg. In conjunction with other muscles of the lower extremity, the great bulk of the thigh is responsible for the powerful movements involved in walking and running, and creates the strength required to prevent the leg from buckling under the weight of the body.

Male raised knee

At the junction between the femur and the tibia (shinbone) is the knee, which is the largest and most sophisticated joint of the body. Here, two tough cushions of fibrous tissue separate the ends of the femur and tibia, absorbing force as it is transmitted up the leg. The front of the knee is protected by the patella, a familiar disk of bone that can clearly be seen beneath the skin.

Female legs and torso

As in the forearm, the skeleton of the lower leg consists of two bones running parallel to each other: the tibia and the fibula. The tibia is the stronger of the two and carries the weight of the body, while the slender fibula serves as an anchoring point for muscles. Visible at the back of the lower leg is the distinctive curvature of the calf muscles, which transmit force through the Achilles tendon in order to lift the heel and straighten the foot, actions that are essential for creating forward propulsion when walking and running.

At the base of the tibia and fibula is a collection of bones that form the skeleton of the ankle and foot. Tough ligaments hold these bones in an archlike configuration that maximizes the ability of the foot to carry weight, and running along their length is a network of tendons that create the movements of the ankle, foot, and toes.

Seated female with legs bent

Detail of leg

Drawing tips

- There are several landmarks to look for when drawing the lower extremity, such as the position of the pelvis, knee, and anklebones.

- You will find that there may be some foreshortening in a seated or lying figure. Bear in mind that it is very easy to make the legs too large if they are closest to you, so several exploratory lines may be needed

before the correct appearance is achieved.

- You could use the head as a unit of measurement, making faint marks on the paper as you figure out the proportions.

Detail of foot

118

The legs

The skeleton of the leg

The main bones of the leg are the femur, which is the bone of the thigh and the largest bone in the body, and the tibia and fibula, which are bones of the lower leg. Additional bones are the patella (kneecap) and the bones of the foot, which consist of the tarsals, metatarsals, and phalanges. The upper end of the femur meets the pelvis at the hip joint, which connects the leg to the trunk.

a KEY TO THE BONES OF THE LEG: ANTERIOR VIEW
1 Hipbone
2 Sacrum
3 Femur
4 Patella
5 Tibia
6 Fibula
7 Tarsals
8 Metatarsals
9 Phalanges

b KEY TO THE BONES OF THE LEG: LATERAL VIEW
1 Hipbone
2 Sacrum
3 Femur
4 Patella
5 Tibia
6 Fibula
7 Tarsals
8 Metatarsals
9 Phalanges

c KEY TO THE BONES OF THE LEG: POSTERIOR VIEW
1 Hipbone
2 Sacrum
3 Femur
4 Tibia
5 Fibula
6 Tarsals
7 Metatarsals
8 Phalanges

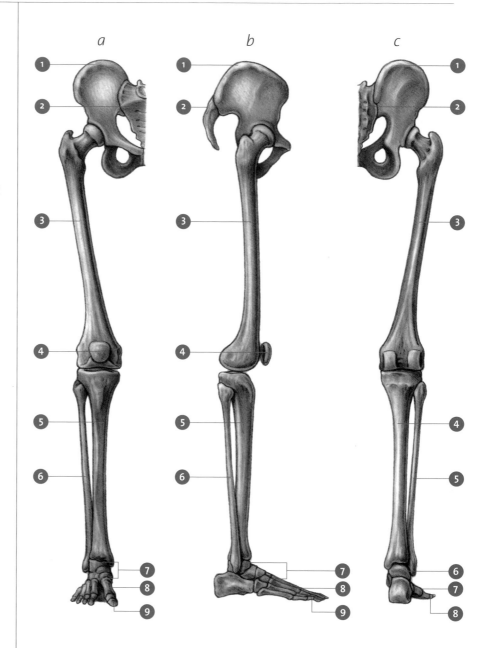

a *b* *c*

The bones of the pelvis

The pelvis is a basin-shaped ring of bone that protects and supports internal organs such as the bladder, and connects the lower limbs to the trunk. It consists of four bones: the sacrum and coccyx, which are found at the base of the spinal column, and the two hipbones. The hipbones each consist of three parts—the ischium, ilium, and pubis—and are attached to the auricular surfaces of the sacrum at the sacroiliac joints. The acetabulum, which is a cup-shaped recess in the side of the hipbone, accommodates the round head of the femur to form the hip joint.

a KEY TO THE SACRUM AND COCCYX: ANTERIOR VIEW
1 Sacral foramin
2 Fusion of vertebral bodies
3 Coccygeal cornua

b KEY TO THE HIPBONE
1 Pubic symphysis
2 Pubic tubercle
3 Ischium
4 Iliac crest
5 Anterior superior iliac spine
6 Anterior inferior iliac spine
7 Acetabulum
8 Femur

c KEY TO THE RELATIONSHIP OF THE SACRUM TO THE LUMBAR VERTEBRAE
1 L4
2 L5
3 Auricular surface
4 Median crest
5 Coccygeal cornu
6 Coccyx

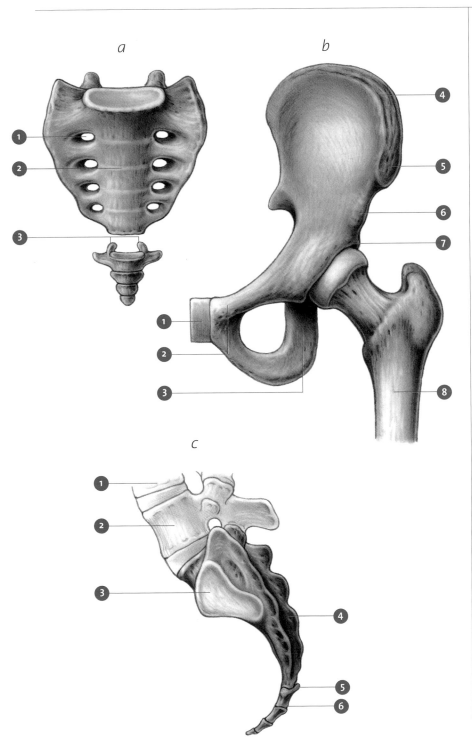

a

b

c

120

The pelvis

The male pelvis

The pelvis consists of a basin-like ring of bone formed of the hipbones, the sacrum, and the coccyx. Each hipbone consists of three components that fuse together during development: the ilium, the ischium, and the pubic bone. The hipbones unite at the front at the pubic symphysis, and at the back they meet the sacrum, which lies at the base of the vertebral column. The pelvis transfers the weight of the trunk to the legs and provides a point of attachment for muscles: as a result, it is generally bulkier in men than in women.

a KEY TO THE MALE PELVIS:
VENTRAL VIEW
1 Vertebral column
2 Pelvis
3 Femur

b KEY TO THE MALE PELVIS:
ANTERIOR VIEW
1 Iliac crest
2 Sacrum
3 Pubic bone
4 Ischium
5 Acetabulum
6 Pubic symphysis

c KEY TO THE MALE PELVIS:
LATERAL VIEW
1 Iliac crest
2 Coccyx
3 Ischium
4 Pubic bone

d KEY TO THE MALE PELVIS:
POSTERIOR VIEW
1 Iliac crest
2 Sacrum
3 Coccyx
4 Ischium

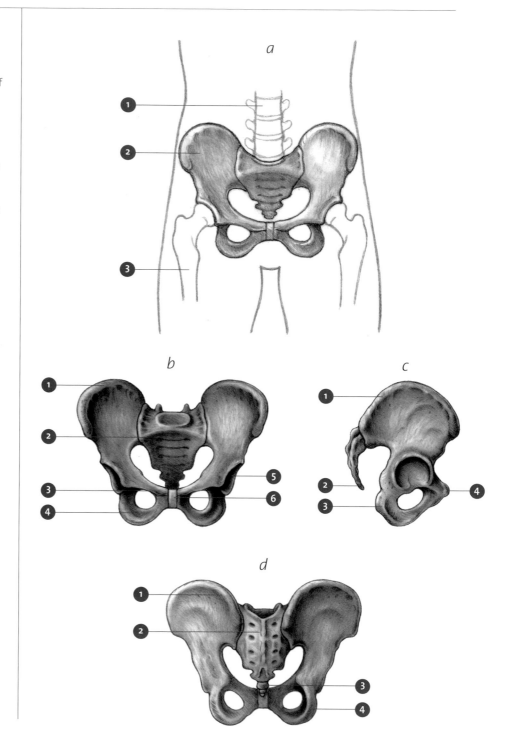

The female pelvis

The fetus must pass through the pelvis during childbirth, so in general the openings of the pelvis are wider in women than in men. Other differences may also be seen: for example, in the female pelvis, the sacrum, and coccyx are often straighter, and the angle beneath the pubis symphysis is typically wider than in the male.

a **KEY TO THE FEMALE PELVIS: VENTRAL VIEW**
1 Vertebral column
2 Pelvis
3 Femur

b **KEY TO THE FEMALE PELVIS: ANTERIOR VIEW**
1 Iliac crest
2 Sacrum
3 Pubic bone
4 Ischium
5 Acetabulum
6 Pubic symphysis

c **KEY TO THE FEMALE PELVIS: LATERAL VIEW**
1 Iliac crest
2 Coccyx
3 Ischium
4 Pubic bone

d **KEY TO THE FEMALE PELVIS: POSTERIOR VIEW**
1 Iliac crest
2 Sacrum
3 Coccyx
4 Ischium

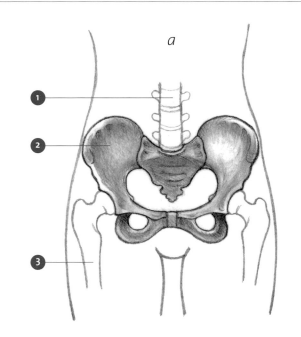

a

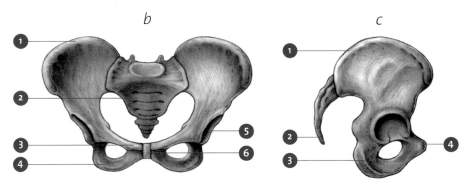

b

c

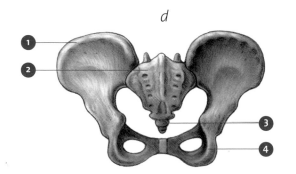

d

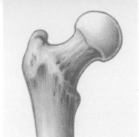

122

The legs

The femur

The femur is a large, sturdy bone that extends from the pelvis to the knee. At its upper end are the head and the neck, which project at an angle away from the main shaft of the bone, and the trochanters, which provide points of attachment for muscles. The shaft of the femur is angled inward, so that the lower end lies closer to the midline of the body than the upper end. At the base of the shaft are the condyles, which meet the tibia to form the knee joint. The patella rests against the front of the lower end of the femur.

a KEY TO THE RIGHT FEMUR:
ANTERIOR VIEW
1 Greater trochanter
2 Shaft
3 Lateral epicondyle
4 Lateral condyle
5 Patellar surface
6 Head
7 Neck
8 Lesser trochanter
9 Medial epicondyle
10 Medial condyle

b KEY TO THE RIGHT FEMUR:
LATERAL VIEW
1 Head
2 Neck
3 Shaft

c KEY TO THE RIGHT FEMUR:
POSTERIOR VIEW
1 Head
2 Neck
3 Shaft
4 Linea aspera
5 Medial supracondylar ridge
6 Lateral supracondylar ridge
7 Intercondylar fossa

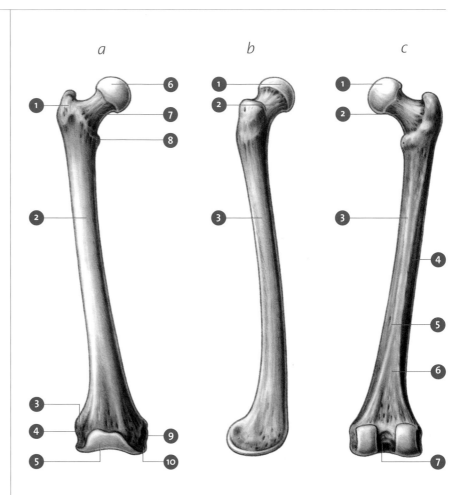

a *b* *c*

POSITION OF THE FEMUR

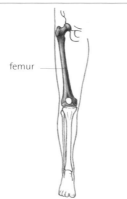

femur

The tibia

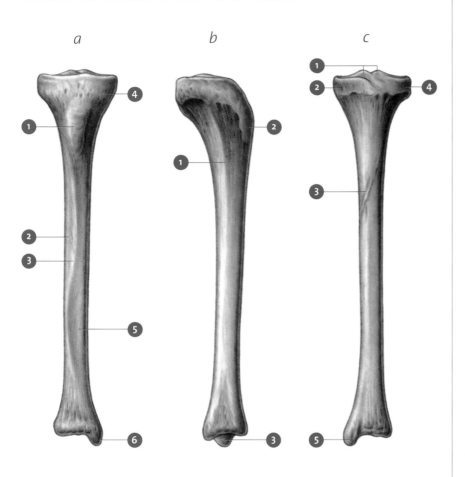

The tibia is one of the two bones of the lower leg and is also known as the shinbone. It supports most of the weight of the body when standing, so is bulky in shape. The upper end of the tibia forms the knee joint with the condyles of the femur, whereas the lower end meets the talus bone of the foot to form the ankle joint. Running down the upper part of the shaft is a ridge called the soleal line, which provides a point of attachment for soleus, one of the calf muscles. The medial malleolus can easily be felt beneath the skin as a distinctive lump of bone on the inner surface of the ankle.

a KEY TO THE RIGHT TIBIA:
ANTERIOR VIEW
1 Tibial tuberosity
2 Interosseous border
3 Anterior border
4 Medial condyle
5 Medial surface
6 Medial malleolus

b KEY TO THE RIGHT TIBIA:
LATERAL VIEW
1 Interosseous border
2 Tibial tuberosity
3 Medial malleolus

c KEY TO THE RIGHT TIBIA:
POSTERIOR VIEW
1 Tubercles of intercondylar eminence
2 Groove on medial condyle
3 Soleal line
4 Lateral condyle
5 Medial malleolus

POSITION OF THE TIBIA

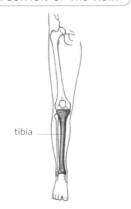

tibia

The legs

The fibula

The fibula is a long slender bone that runs parallel to the tibia. Unlike the tibia, it does little to support the weight of the body: instead its main role is to provide a point of attachment for muscles of the lower leg. Its upper and lower ends are attached to the tibia, and its lower end also forms a joint with the talus bone of the foot. The lateral malleolus can be felt as a bony lump beneath the skin on the outer surface of the ankle.

a **KEY TO THE FIBULA:**
ANTERIOR VIEW
1 Apex
2 Head
3 Shaft
4 Lateral malleolus

b **KEY TO THE FIBULA:**
LATERAL VIEW
1 Apex
2 Head
3 Lateral malleolus

c **KEY TO THE FIBULA:**
POSTERIOR VIEW
1 Apex
2 Head
3 Lateral malleolus

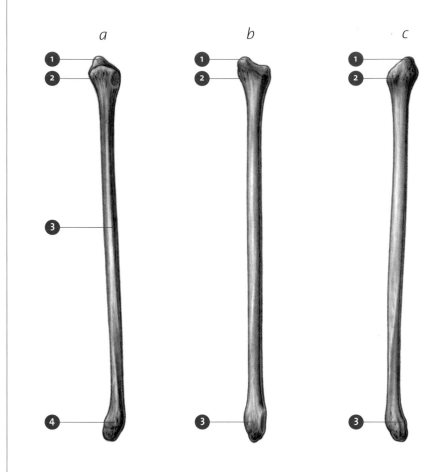

a *b* *c*

POSITION OF THE FIBULA

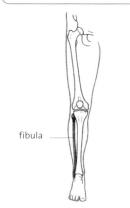

fibula

The patella

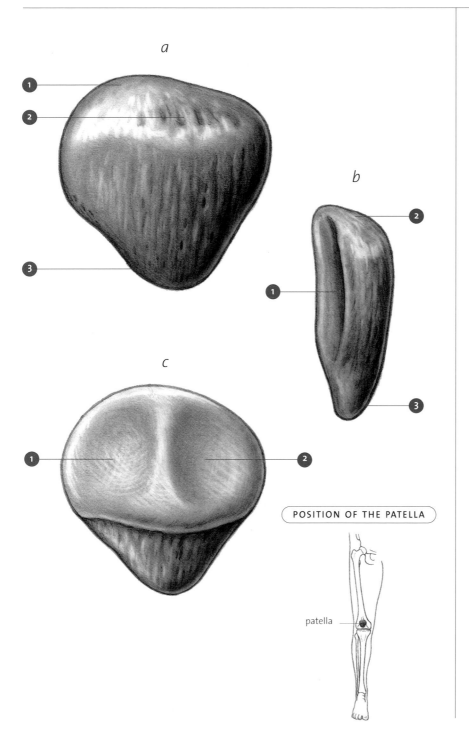

a

b

c

POSITION OF THE PATELLA

patella

The patella is a disk that lies in front of the lower end of the femur. It is embedded in a strip of fibrous tissue that extends from the lower end of the quadriceps muscle (the bulky muscle of the thigh) to the tibia. The patella helps to transfer force across the knee joint when the thigh muscles contract in order to straighten the leg.

a **KEY TO THE PATELLA: ANTERIOR VIEW**
1 Base
2 Attachment of rectus femoris muscle
3 Apex

b **KEY TO THE PATELLA: LATERAL VIEW**
1 Facet for lateral condyle of femur
2 Base
3 Apex

c **KEY TO THE PATELLA: POSTERIOR VIEW**
1 Facet for medial condyle of femur
2 Facet for lateral condyle of femur

126

The skeleton of the foot

The skeleton of the foot consists of the tarsus, the metatarsals, and the phalanges. The tarsus is a collection of seven bones: the talus (anklebone), the calcaneus (heelbone), the cuboid and navicular bones, and the three calcaneal bones, which are arranged in a row. The metatarsals and phalanges are the bones of the front of the foot and the toes and form a column of bones for each digit, as do the metecarpals and phalanges of the hand. Each toe has three phalanges, except for the big toe, which has only two.

a KEY TO THE BONES OF THE FOOT: DORSAL VIEW
1 Phalanges
2 Metatarsals
3 Cuneiform bones
4 Navicular bone
5 Neck of talus
6 Trochlear surface of talus
7 Posterior talar process
8 Cuboid bone
9 Calcaneus

b THE BONES OF THE FOOT: PLANTAR VIEW
1 Phalanges
2 Metatarsals
3 Cuneiform bones
4 Navicular bone
5 Cuboid bone
6 Neck of talus
7 Talus

c THE BONES OF THE FOOT: LATERAL VIEW
1 Trochlear surface of talus
2 Calcaneus
3 Navicular bone
4 Cuneiform bones
5 Metatarsals
6 Phalanges
7 Cuboid bone

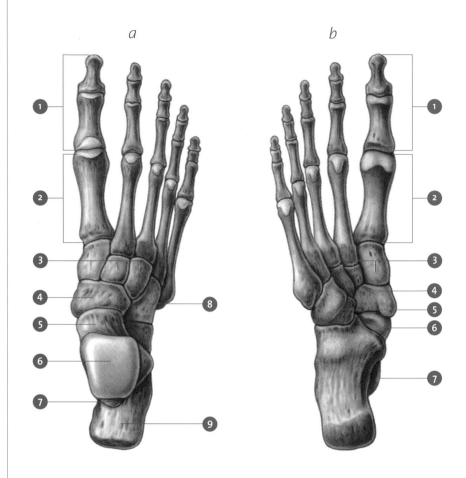

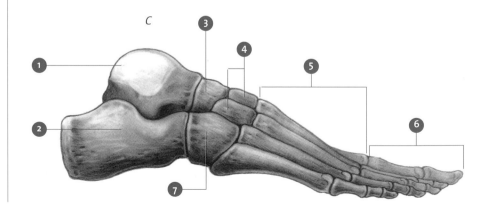

The skeleton of the foot

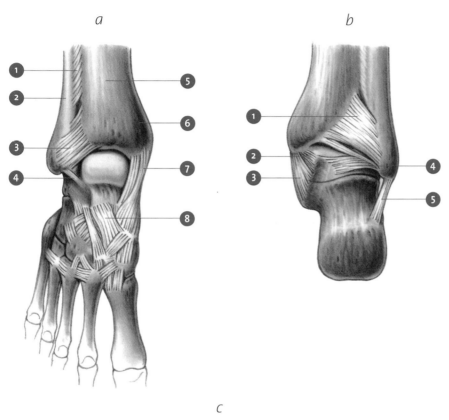

a

b

c

Numerous straps of fibrous tissue support the joints and hold the complex skeleton of the foot together. Particularly important are the deltoid ligament, which extends from the lower end of the tibia to the talus, calcaneus, and navicular bone, and the anterior and posterior tibiofibular ligaments, which bind the lower ends of the tibia and fibula to each other. With the tibia and fibula held in a stable position, the medial and lateral malleoli form a deep socket into which the trochlear surface of the talus inserts, giving great stability to the ankle joint.

a KEY TO THE LIGAMENTS OF THE FOOT: DORSAL VIEW
1 Interosseous membrane
2 Fibula
3 Anterior tibiofibular ligament
4 Anterior talofibular ligament
5 Tibia
6 Medial malleolus
7 Deltoid ligament (tibionavicular part)
8 Talonavicular ligament

b KEY TO THE LIGAMENTS OF THE FOOT: POSTERIOR VIEW
1 Posterior tibiofibular ligament
2 Deltoid ligament (posterior tibiotalar part)
3 Deltoid ligament (tibiocalcaneal part)
4 Posterior talofibular ligament
5 Calcaneofibular ligament

c KEY TO THE LIGAMENTS OF THE FOOT: LATERAL VIEW
1 Anterior tibiofibular ligament
2 Calcaneofibular ligament

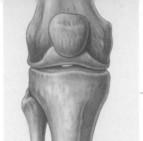

128

The knee

The knee joint

The knee joint is one of the largest joints of its type in the body. It consists of three parts: two are formed by the connections between the condyles of the femur and the tibia, and one by the connection between the femur and the patella.

a KEY TO THE KNEE JOINT:
ANTERIOR VIEW
1 Femur
2 Lateral epicondyle of femur
3 Lateral condyle of femur
4 Fibula
5 Patella
6 Medial epicondyle of femur
7 Medial condyle of femur
8 Tibia
9 Tuberosity of tibia

b KEY TO THE KNEE JOINT:
LATERAL VIEW
1 Femur
2 Tibia
3 Fibula
4 Patella
5 Lateral condyle of femur
6 Tuberosity of tibia

c THE KNEE JOINT:
POSTERIOR VIEW
1 Femur
2 Medial condyle of femur
3 Medial condyle of tibia
4 Tibia
5 Intercondylar notch
6 Lateral condyle of femur
7 Lateral condyle of tibia
8 Fibula

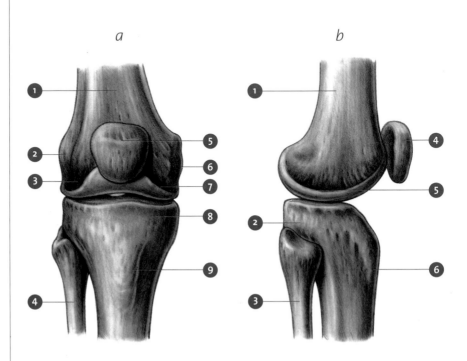

a

b

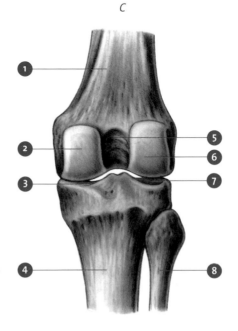

c

The knee joint

The condyles of the femur and tibia are separated by pads of tissue called menisci, which create an improved fit between the condyles. The collateral ligaments run down each side of the knee joint and prevent the lower leg from bending from side to side at the knee joint. Further stability is provided by the cruciate ligaments; the anterior cruciate ligament prevents the upper end of the tibia from sliding forward out of the knee joint, and the posterior cruciate ligament prevents it from sliding backward.

a **KEY TO THE RIGHT KNEE JOINT: POSTERIOR VIEW**
1 Medial condyle of femur
2 Medial meniscus
3 Posterior cruciate ligament
4 Medial collateral ligament
5 Tibia
6 Anterior cruciate ligament
7 Lateral meniscus
8 Lateral collateral ligament
9 Fibula

b **DIAGRAM TO SHOW HOW THE CRUCIATE LIGAMENTS STABILIZE THE KNEE JOINT**
1 Posterior cruciate ligament
2 Anterior cruciate ligament

a

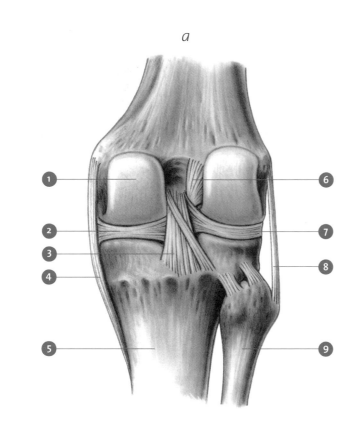

b

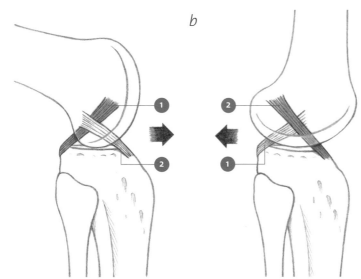

130

The thigh

The muscles of the thigh

Numerous long, powerful muscles run along the length of the thigh. These can be classified into three groups: those at the front of the thigh extend the leg at the knee, those at the back of the thigh flex it, and those that run down the inner thigh draw the leg inward, toward the opposite leg. The main muscle of the front of the thigh is quadriceps, which consists of four smaller muscles that work together to straighten the knee. The main flexors of the knee are known as the hamstrings.

a KEY TO THE MUSCLES OF
THE THIGH: ANTERIOR VIEW
1 Tensor fasciae latae
2 Rectus femoris
3 Vastus lateralis
4 Iliopsoas
5 Pectineus
6 Adductor longus
7 Gracilis
8 Sartorius
9 Vastus medialis

b KEY TO THE MUSCLES OF
THE THIGH: LATERAL VIEW
1 Gluteus medius
2 Gluteus maximus
3 Iliotibial tract
4 Biceps femoris
5 Tensor fasciae latae
6 Rectus femoris
7 Vastus lateralis

c KEY TO THE MUSCLES OF
THE THIGH: POSTERIOR VIEW
1 Gluteus maximus
2 Adductor magnus
3 Semitendinosus
4 Semimembranosus
5 Gluteus medius
6 Biceps femoris

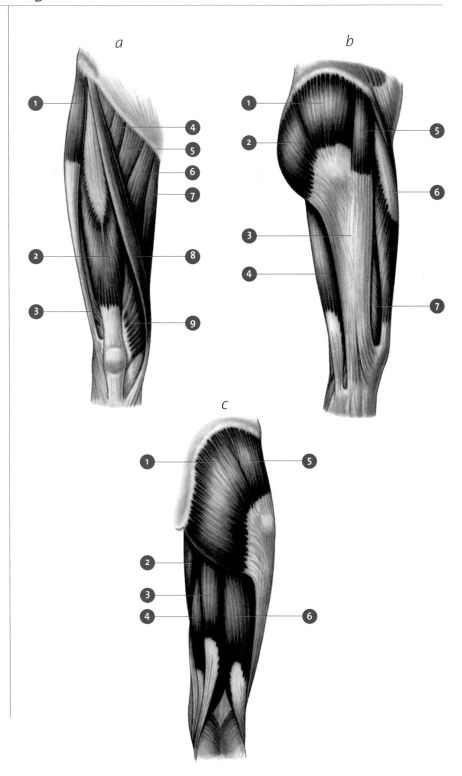

a

b

c

The muscles of the thigh

Movements of the leg at the hip are brought about by three groups of muscles. Iliacus and psoas muscles arise from the vertebral column and internal surface of the pelvis, and they flex the hip in conjunction with sartorius and a smaller muscle called pectineus. Extension of the hip is carried out by the hamstrings and by the gluteal muscles (muscles of the buttock region), which also contribute to other movements of the thigh, such as rotation. Finally, muscles of the inner thigh such as adductor longus draw the hip inward, so that the leg moves toward the opposite leg.

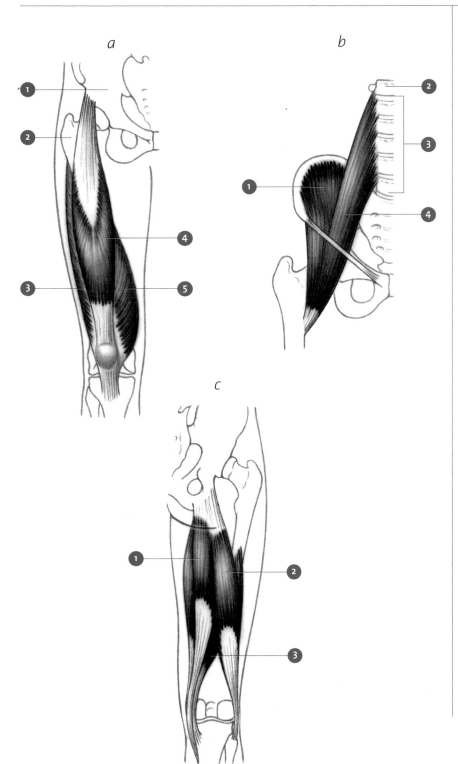

a KEY TO THE MUSCLES OF
THE THIGH: ANTERIOR VIEW
1 Pelvis
2 Femur
3 Vastus lateralis
4 Rectus femoris
5 Vastus medialis

b KEY TO THE FLEXORS OF
THE HIP: ANTERIOR VIEW
1 Iliacus
2 Thoracic vertebra 12
3 Lumbar vertebrae 1-5
4 Psoas

c KEY TO THE HAMSTRING
MUSCLES: POSTERIOR VIEW
1 Semitendinosus
2 Biceps femoris
3 Semimembranosus

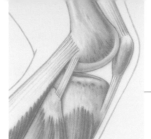

132

The knee

Muscles and bones of the knee region

Movements of the knee are produced by quadriceps, which straightens the knee, and by the hamstrings, which bend it. Surrounding the knee joint are powerful tendons that arise from these muscles. The quadriceps tendon inserts into the upper surface of the patella, which in turn gives rise to the patellar ligament, the lower end of which is attached to the tibia. The force of contraction of quadriceps is therefore transferred via the patella and the patella ligament to the tibia, resulting in straightening of the knee.

a SECTION TO SHOW BASIC
STRUCTURE OF THE KNEE
1 Quadriceps
2 Femur
3 Patella
4 Joint capsule
5 Patellar ligament
6 Tibia

b KEY TO MUSCLES OF THE
KNEE REGION: MEDIAL VIEW
1 Vastus medialis
2 Patellar
3 Sartorius
4 Gastrocnemius

c DRAWING TO SHOW
EXTENSION OF THE KNEE
BY THE ACTION OF THE
QUADRICEPS MUSCLE
1 Patella
2 Fibula
3 Distal end of femur
4 Tibia
5 Patellar ligament

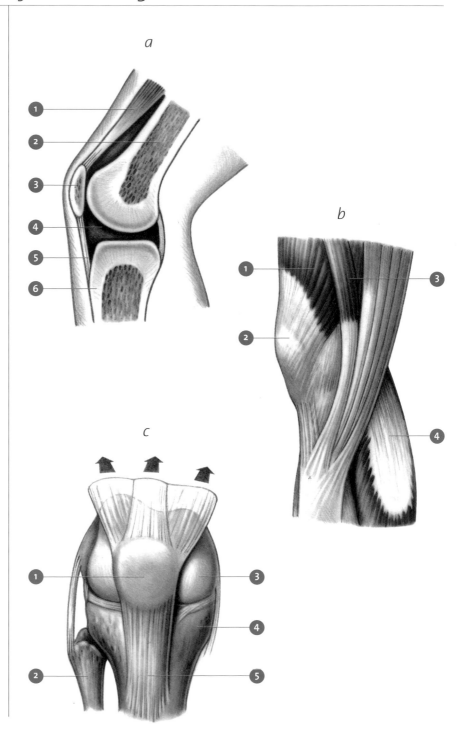

Muscles and bones of the knee region

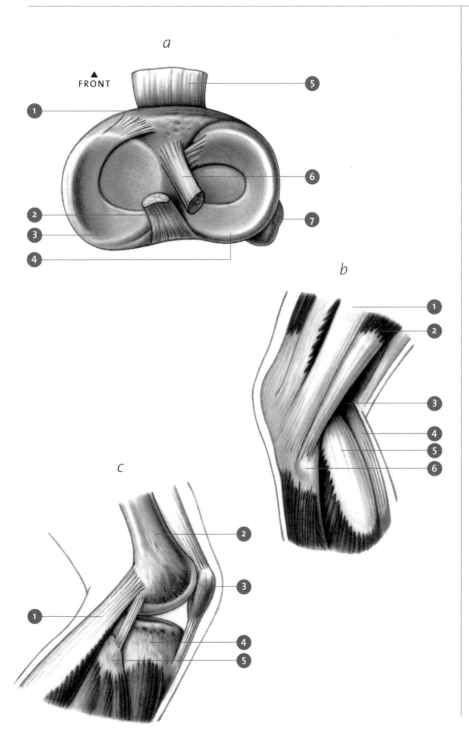

a

FRONT

b

c

Within the knee joint are two crescent-shaped pieces of tissue called the menisci, which produce a close fit between the condyles of the femur and the tibia. The anterior and posterior cruciate ligaments extend between the tibia and the femur in order to add stability to the joint. Gastrocnemius, which acts upon the ankle joint, arises from the lower end of the femur, just above the knee joint. The gap between the upper edges of gastrocnemius and the lower edges of biceps femoris and semimembranosus forms a depression at the back of the knee called the popliteal fossa.

a VIEW OF RIGHT KNEE JOINT: SUPERIOR VIEW
1 Tibia
2 Posterior cruciate ligament
3 Medial meniscus
4 Lateral meniscus
5 Patellar ligament (cut)
6 Anterior cruciate ligament
7 Fibula

b VIEW TO SHOW POPLITEAL FOSSA: POSTERO-LATERAL VIEW
1 Iliotibial tract
2 Biceps femoris
3 Popliteal fossa
4 Medial head of gastrocnemius
5 Lateral head of gastrocnemius
6 Head of fibula

c VIEW TO SHOW ATTACHMENT OF GASTROCNEMIUS: LATERAL VIEW
1 Lateral head of gastrocnemius
2 Femur
3 Patella
4 Tibia
5 Fibula

134

The lower leg

The muscles of the lower leg

Muscles of the lower leg act upon the ankle joint and upon joints within the foot. At the back of the lower leg, the calf muscles tilt the foot at the ankle so that the toes point downward. Of these muscles, gastrocnemius, soleus, and plantaris give rise to the thick, powerful Achilles tendon, which inserts into the back of the calcaneus bone of the foot. Muscles at the front of the lower leg tilt the foot at the ankle so that the toes point upward. Additional muscles tilt the foot from side to side and move the toes.

a **KEY TO LOWER LEG MUSCLES: ANTERIOR VIEW**
1 Tibialis anterior
2 Extensor digitorum longus
3 Peroneus longus
4 Tibia
5 Gastrocnemius
6 Soleus
7 Flexor retinaculum

b **KEY TO LOWER LEG MUSCLES: POSTERIOR VIEW**
1 Medial head of gastrocnemius
2 Flexor digitorum longus
3 Tendon of tibialis posterior
4 Achilles tendon
5 Lateral head of gastrocnemius
6 Soleus

c **KEY TO LOWER LEG MUSCLES: LATERAL VIEW**
1 Tendon of biceps femoris
2 Head of fibula
3 Gastrocnemius
4 Soleus
5 Peroneus brevis
6 Tibialis anterior
7 Extensor digitorum longus
8 Peroneus longus
9 Peroneus tertius

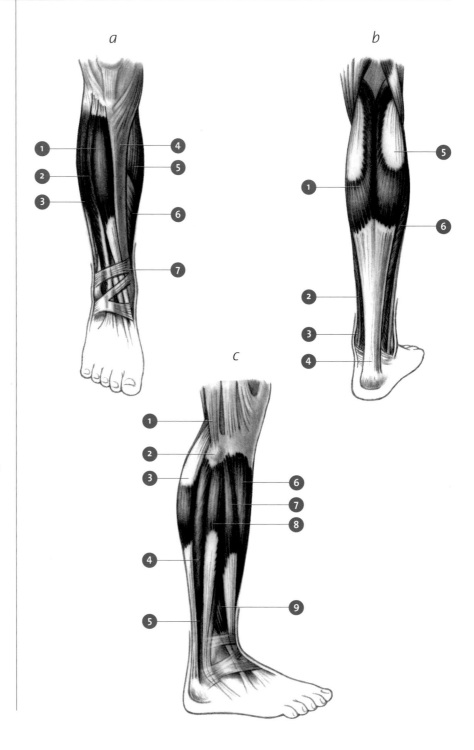

The muscles of the lower leg

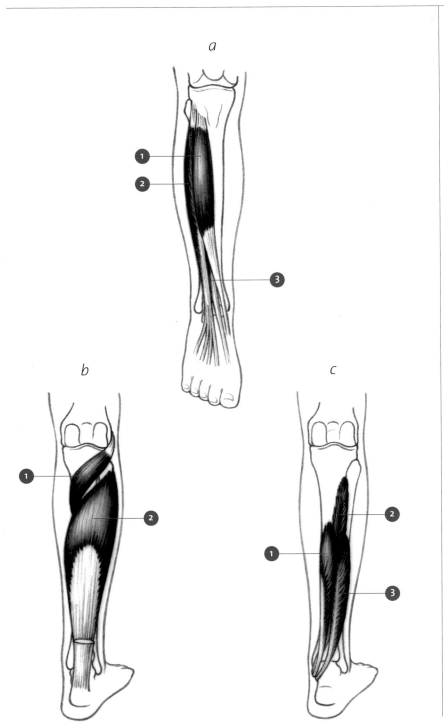

At the front of the lower leg, extensor hallucis longus and extensor digitorum longus bend the toes upward, while the tibialis anterior elevates and twists the foot inward at the ankle joint. Muscles at the back of the lower leg generally do the opposite: flexor hallucis longus and flexor digitorum longus bend the toes downward, and muscles such as tibialis posterior and soleus tilt the foot at the ankle so that the toes point to the ground.

a KEY TO LOWER LEG
MUSCLES: ANTERIOR VIEW
1 Tibialis anterior
2 Extensor digitorum longus
3 Extensor hallucis longus

b KEY TO LOWER LEG
MUSCLES: POSTERIOR VIEW
1 Popliteus
2 Soleus

c KEY TO LOWER LEG
MUSCLES: POSTERIOR VIEW
1 Flexor digitorum longus
2 Tibialis posterior
3 Flexor hallucis longus

136

The feet

The muscles of the feet

Movements of the foot are produced by muscles of the lower leg, which transmit their forces along long tendons, and by muscles located within the foot itself. The main movements of the foot consist of bending and straightening the toes, inversion, and eversion (turning the foot inward and outward) and dorsiflexion and plantarflexion (raising and lowering the foot at the ankle). Complex sequences of these movements are involved in walking.

a KEY TO FOOT MUSCLES:
DORSAL VIEW
1 Tendon of extensor digitorum longus
2 Tendon of extensor hallucis longus
3 Extensor digitorum brevis

b KEY TO FOOT MUSCLES:
DORSAL VIEW
1 Extensor digitorum brevis

c KEY TO FOOT MUSCLES:
LATERAL VIEW
1 Inferior extensor retinaculum
2 Tendon of peroneus brevis
3 Tendon of peroneus longus
4 Tendon of extensor digitorum longus
5 Tendon of peroneus tertius
6 Extensor digitorum brevis

d DETAIL SHOWING THE
INTEROSSEUS MUSCLES
The interosseus muscles of the foot lie in between the metatarsal bones, just as the interosseus muscles of the hand lie in between the metacarpals. Their function is to move the toes from side to side.

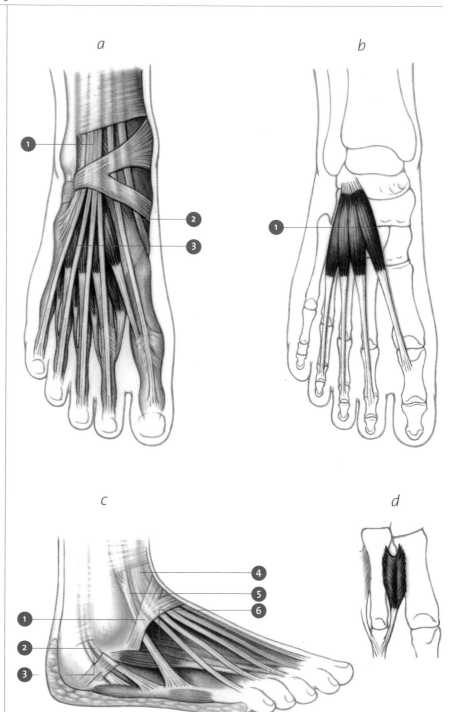

a

b

c

d

The muscles of the feet

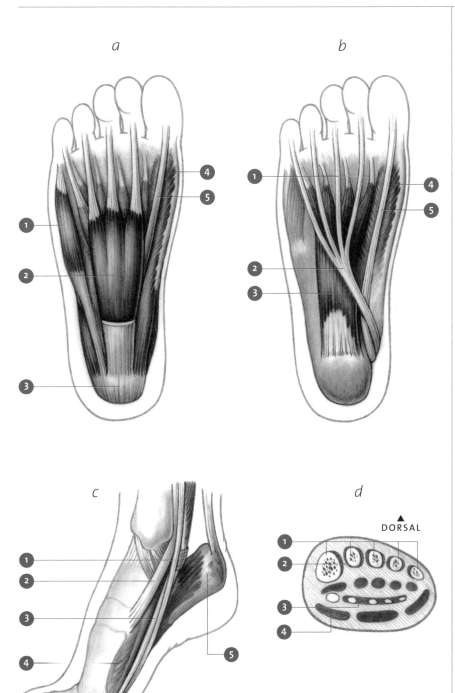

a

b

c

d

▲
DORSAL

The intrinsic muscles of the sole of the foot are chiefly concerned with movements of the toes.

a KEY TO FOOT MUSCLES: DORSAL VIEW
1 Abductor digiti minimi
2 Flexor digitorum brevis
3 Calcaneus
4 Flexor hallucis brevis
5 Tendon of flexor hallucis longus

b KEY TO FOOT MUSCLES: PLANTAR VIEW
1 Lumbricals
2 Tendon of flexor digitorum longus
3 Quadratus plantae
4 Flexor hallucis brevis
5 Tendon of flexor hallucis longus

c KEY TO FOOT MUSCLES: MEDIAL VIEW
1 Tendon of flexor digitorum longus
2 Tendon of tibialis posterior
3 Tendon of flexor hallucis longus
4 Abductor hallucis
5 Calcaneus

d THE FOUR MUSCLE LAYERS
1 Muscle layer 1 consists of abductor digiti minimi, flexor digitorum brevis, and abductor hallucis
2 Muscle layer 2 consists of the umbricals
3 Muscle layer 3 consists of flexor hallucis brevis, adductor hallucis, and flexor digiti minimi brevis
4 Muscle layer 4 consists of the interossei

138

The feet

Drawing the feet at rest

Feet can sometimes be difficult to draw, so it may be necessary to start with a few exploratory lines before they begin to look right.

STEP 1
Draw the basic shape of the foot with a few straight lines and check that these are correct. Indicate the angle of the ankle joint and curved lines to mark the position of the toe joints.

STEP 2
Develop the tonal areas of the foot, looking at the way that the light falls on the toe joints and extensor tendons.

STEP 3
Completion. As with the hand, this could be one of several freer studies done on the same sheet of paper.

KEY
1 extensor tendons

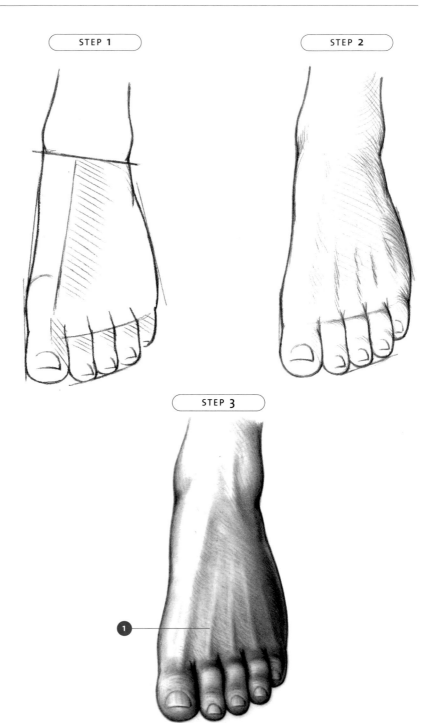

STEP 1

STEP 2

STEP 3

Drawing the feet at rest

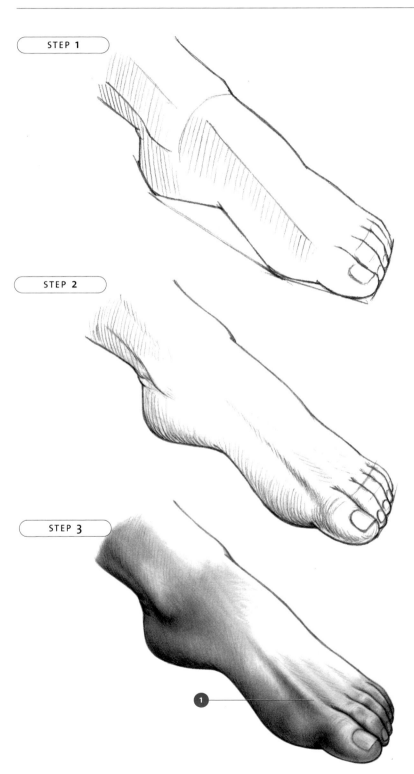

STEP 1

STEP 2

STEP 3

This is a rather more interesting view, with light coming from the left of the subject, which accentuates the form of the ankle joint and right side of the foot. This position gives you an opportunity to draw some expressive curves from the heel to the big toe.

STEP 1
Draw a few straight lines to get the general shape down on paper, looking at the plane changes, here shown with straight lines.

STEP 2
Based on these plane changes, start to draw some smooth flowing lines and render the most obvious tonal areas first. Check the position of joints and toenails.

STEP 3
Complete by strengthening some lines and adding surface details.

KEY
1 extensor tendons

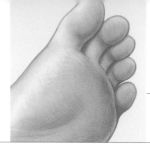

The feet

Drawing the feet when flexing

Notice how the toes are flattened, and also the form of the Achilles tendon and other tendons passing behind the lateral malleolus of the fibula. There is also a more abrupt plane change on the surface of the foot than in the previous drawing.

STEP 1
Start with basic outline of the foot as described on the previous pages.

STEP 2
Work on strengthening the outline, especially on that part of the foot that is closest to the ground. Draw in the position of the tendons and ankle joint.

STEP 3
Complete the surface details, especially around the toes.

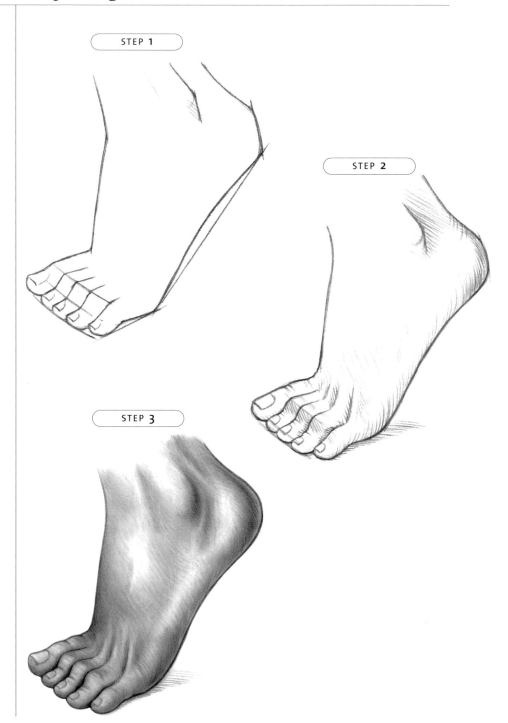

STEP 1

STEP 2

STEP 3

Drawing the feet when flexing

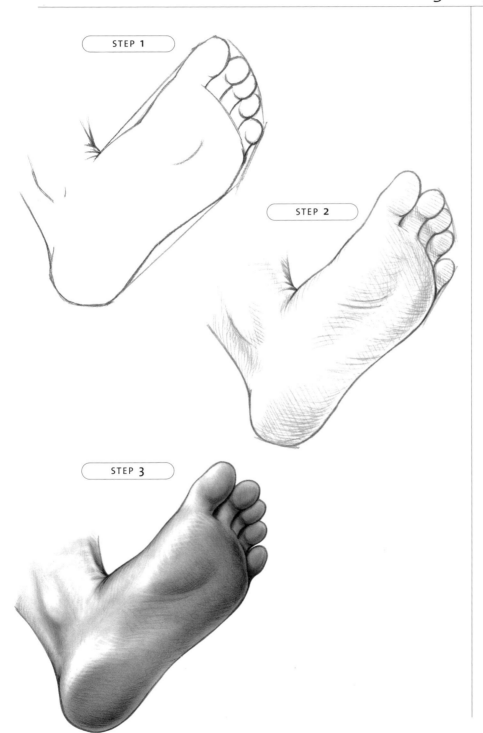

This more unusual view shows the parts of the foot that are load bearing. As with the palmar surfaces of the hands, these surfaces of the feet are softer and more cushioned because they have to bear the weight of the body.

STEP 1
Start the drawing in the same way as previously, with a few lines to get the proportions looking right.

STEP 2
Observe the angle of the leg compared to the foot and make the lines stronger on that part of the foot that is closest to you.

STEP 3
Complete by gradually building up the tones and creases on the sole, giving the toes a feeling of roundness with reflected light.

The legs

Drawing the legs

The shape of the legs can be greatly affected by body type, and many of the bony features and muscle forms may not be as obvious in some individuals as the examples shown here. When drawing the legs, remember how they are connected to the lower part of the torso, and try to visualize the structures beneath the skin.

STEP 1
Take the initial measurements across the hips, from the top of the leg to the knee, and from the knee to the ankle and foot. Notice the contour line on the surface of the thigh. Draw in the outlines of the legs and observe the plane changes between the torso, upper and lower leg.

DETAIL SHOWING TORSO, UPPER AND LOWER LEG
1 Anterior superior iliac spine
2 Quadriceps muscle
3 Femur

STEP 2
Sketch in the various landmarks such as the femoral triangle, border of the sartorius muscle, and position of the patella.

STEP 3
Finish by modeling the tones to show the plane changes and details around the knee, such as the upper border of the tibia and the head of the fibula.

DETAIL SHOWING FEMORAL TRIANGLE
1 Inguinal ligament
2 Femoral
3 Sartorius

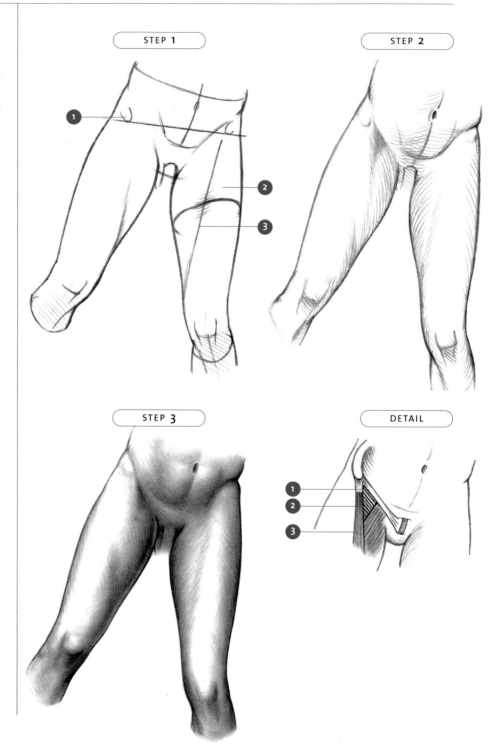

STEP 1

STEP 2

STEP 3

DETAIL

Drawing the legs

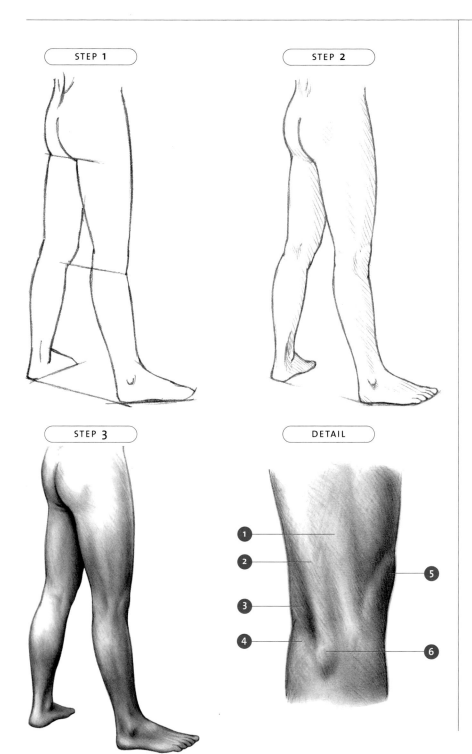

STEP 1

STEP 2

STEP 3

DETAIL

This three-quarter view of a muscular individual shows the gastrocnemius muscles and the iliotibial tract quite well.

STEP 1
Anchor the feet firmly on the ground with a few preliminary lines and take measurements as on page 142.

STEP 2
Draw some strong lines down the legs and observe the direction of light in order to decide how to put in the various areas of tone.

STEP 3
Complete by building up the form of the muscle groups, and strengthen some lines if necessary.

DETAIL OF KNEE
1 Iliotibial tract
2 Biceps femoris
3 Poplitial fossa
4 Lateral head of gastrocnemius
5 Patella
6 Head of fibula

MOVEMENT

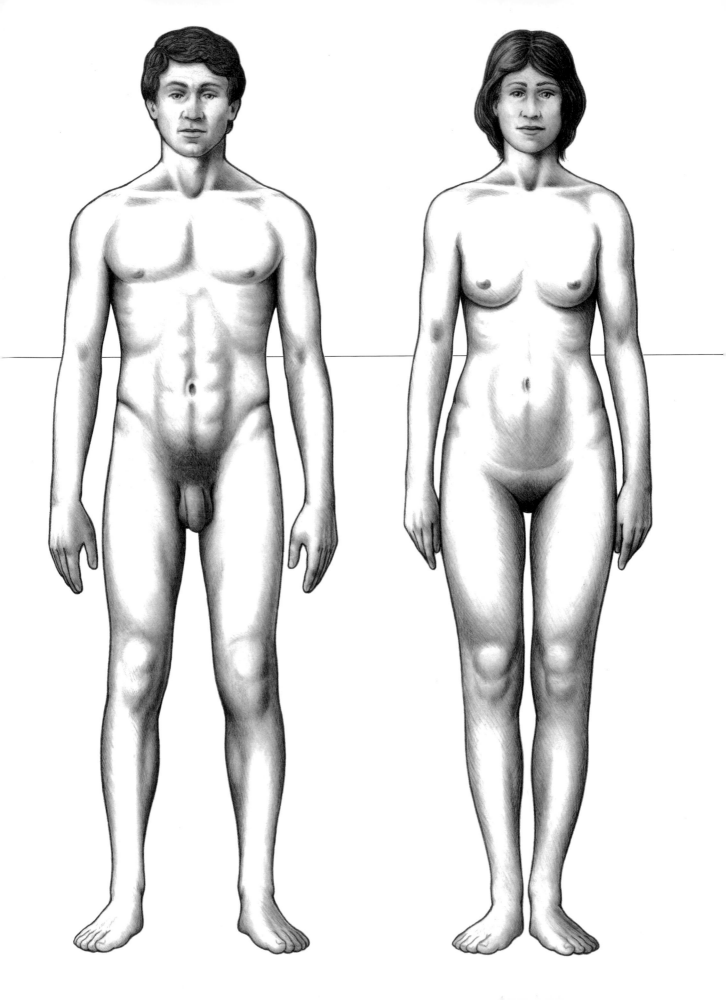

Movement

Movement originates in a region of the brain called the motor cortex, where the nerve impulses that produce muscle contractions arise. Additional areas of the brain, particularly the cerebellum, contribute to these impulses and ensure that movements are smooth and coordinated. Upon leaving the brain, impulses travel down the spinal cord and are relayed to their target muscles, which contract in response. Meanwhile, sensory information about the position of joints and the activity of muscles is relayed back to the spinal cord and brain, allowing the progress of movements to be continually monitored and adjusted.

Three types of muscles are found in the body: smooth muscle, which produces involuntary actions such as the churning of the gut; cardiac muscle, which creates the rhythmic pulsation of the heart; and skeletal muscle, which is responsible for movement. Skeletal muscle consists of numerous parallel bundles of fibers that shorten when activated by nerve impulses, resulting in muscle contraction.

Female playing
forehand stroke

Male moving
dramatically

Movements are classified according to the way in which they alter the position of individual structures in relation to the rest of the body. Hence the main movements are flexion (bending of a part such as the elbow), extension (straightening of a part), abduction (movement of a part out to the side of the body), adduction (movement of a part back toward the centre of the body), and rotation. Complex actions involve a combination of these movements: for example, swinging a tennis racket requires simultaneous flexion, abduction, and rotation of the shoulder joint.

Male playing
backhand stroke

The structure of joints largely determines the range of movements that a body part can carry out. Therefore, the lower leg is only able to flex and extend

Back view of male
muscle structure

because the hingelike knee joint allows very little side-to-side movement. In contrast, the thigh is able to move more freely, because the hip joint, where the rounded head of the humerus (thighbone) inserts into a socket on the side of the pelvis, permits forward, backward, sideway, and rotational movements.

Movements may be described as postural, locomotive, and fine, according to their function. Postural movements consist of broad, powerful contractions of muscles such as those of the back and thigh, which hold the body upright and determine the position of body parts in relation to each other. Locomotive movements are involved in walking and propel the body through space. Lastly, fine movements permit delicate activities such as tying a shoelace. It is rare for one type of movement to occur on its own: lifting a weight, for example, involves postural movements to support the back, shoulder, and arm, while fine movements of the thumb and fingers firmly grip the object.

Female neck
muscle structure

Drawing tips

- Different actions will bring different muscle groups into play, so look for the most obvious ones.

- Try some quick sketches first, concentrating on the essential forms in a figure. Draw in action lines and a few quick strokes, looking at the parts of the body that are closest to you.

- If you have time for a longer study, measure the height of the head with a pencil as described on page 42, and use this method to get the rest of the figure in proportion.

- Try to visualize the skeletons on page 14 in the various poses shown on the following pages, and decide which important landmarks would be visible in each case.

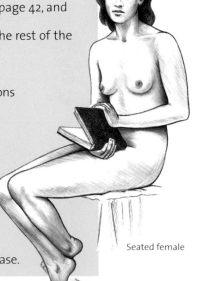

Seated female

The upper body

Movement in the head and neck

The cervical vertebrae allow for much freedom of movement, especially between the top of the spine and the base of the skull. A vertical line drawn through the sternum and sternal notch will help when deciding on the correct angle of the head and neck.

a
In this view, the thyroid cartilage is more obvious, as well as the suprasternal notch and borders of the sternomastoid muscles. The hair has been used to emphasize the shape of the left shoulder.

b
A study using diagonal lines to render light and shade.

c
This shows how the right sternomastoid muscle is twisted as the head is rotated, and the corresponding muscle is shown as a definite border.

d
A quick study showing the head and neck with few lines and concentrating the tone on the hair.

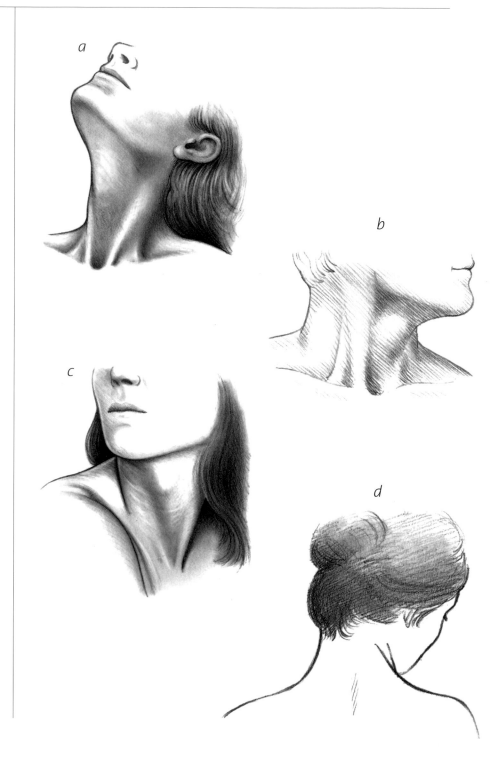

Movement in the arms

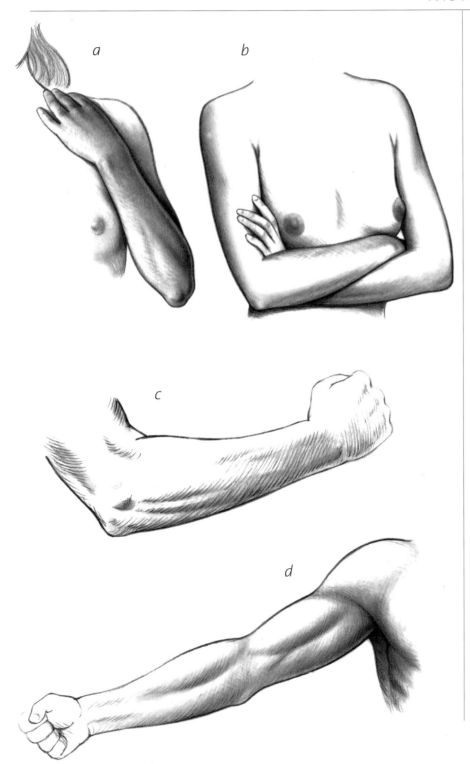

Various studies of the arms treated in slightly different ways.

a
Although there is more emphasis on the forearm, it is also important to see how it comes against the left breast, shown by a slight shadow.

b
A simpler study concentrating on line with a few dark areas.

c
A strong arm with muscles rendered with strokes of the pencil.

d
A drawing that focuses on the upper arm and armpit.

a

b

c

d

150

The lower body

Movement in the hips

There is greater movement possible in the lumbar region of the spine than in the thorax. Strong light and shade will help when modeling the various forms. The anterior superior iliac spines are the bony landmarks common to a, b, and c.

a
A figure rendered with diagonal lines and a basic outline. The fact that this is a male model helps when showing the muscle forms.

b
A female subject with good muscle tone. Notice the appearance of the muscles of the lateral abdominal wall when the trunk is rotated.

c
A softer, more rounded figure, standing on the left leg with the right leg bent slightly.

d
This male figure shows the form of the sacrospinalis muscles, and a deep groove between them as the lumbar spine curves forward. The position of the posterior superior iliac spines is also visible as two dimples.

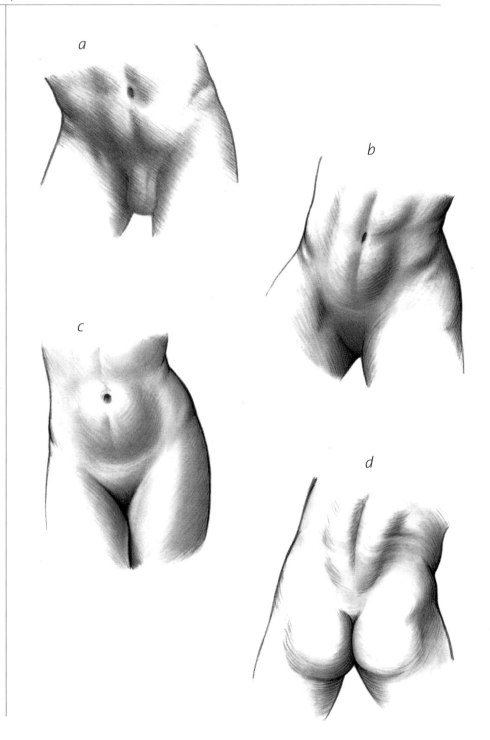

Movement in the legs

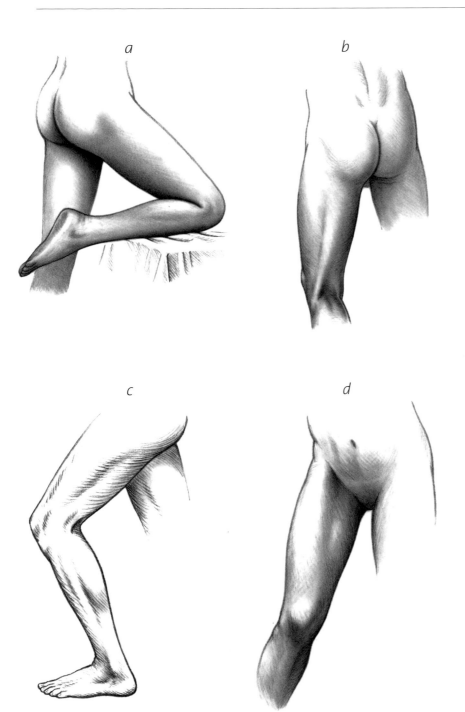

a

b

c

d

These illustrations show the legs done as studies, where not all the details need to be included. Concentrating on certain areas can make for an interesting drawing, with the rest done as simple lines or faintly sketched in.

a
The position of this female figure shows the form of the gastrocnemius muscle and bulging of the area around the knee.

b
A male figure showing the hamstring muscles and tendons as they pass on either side of the popliteal fossa. The two heads of the gastrocnemius muscle can also be seen clearly.

c
A simple rendering of the male leg that shows the iliotibial tract and form of the lower leg.

d
A different view concentrating on the form of the right leg, showing the sartorius muscle and femoral triangle, the border of the tibia, and head of fibula.

The figure

Dividing up the figure

a
The body = 7½ head lengths

b
The body can be divided into
two equal halves AB = BC.
The trunk can be divided into
equal thirds DE = EF = FB.
From the suprasternal fossa to
the tip of the middle finger = ½
the body length.

KEY TO THE STANDING FIGURE
1 ½ body length
2 Suprasternal fossa
3 Xiphoid process of sternum
4 Navel
5 Pubic arch
6 Width across the shoulders =
 2 head lengths

a

Drawing a standing figure

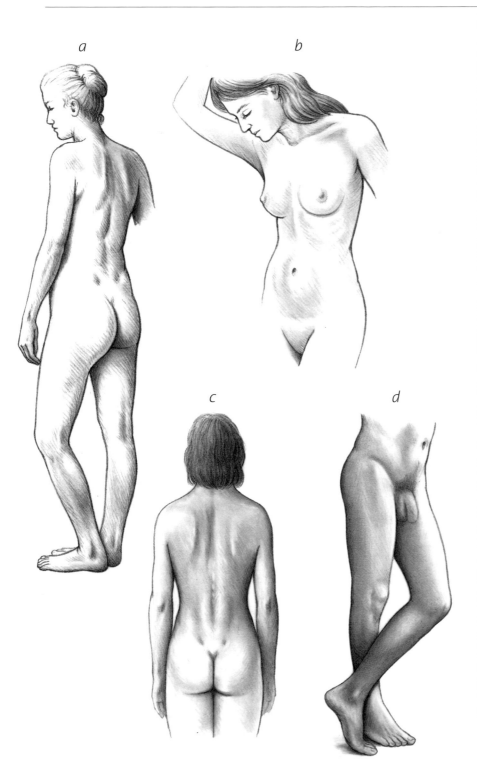

a

b

c

d

These could all be done as quick sketches to loosen up your hand before doing more detailed studies. When drawing standing figures, make sure that they are well balanced. Try to visualize the line of the spine and angle of the pelvis on this figure. Observe the plane changes on the back in particular.

b
This pose was chosen because of the position of the head coming in front of the right arm. The hair could be given the strongest tone in this example to contrast with the lines of the body.

c
A straight view of the back showing the scapulae, position of the spine with obvious processes, and the sacrospinalis muscles.

d
The position of the right foot in this pose is similar to the one shown on page 140.

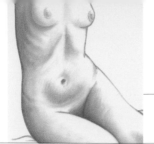
The figure

Drawing the seated figure

Modeling is once again helped by strong lighting, and reflected light is also useful to suggest the roundness of the forms.

a
A few lines to represent drapery can assist in achoring the figure, and also provide a contrast to the smooth lines of the leg.

b
The focus of this study is the modeling of the lower leg.

c
A simple, more linear drawing, which could use the hair as a focal point.

d
The direction of the light shows up the form of the spinous processes on this woman's back, and also suggestions of the rib cage.

Drawing the walking figure

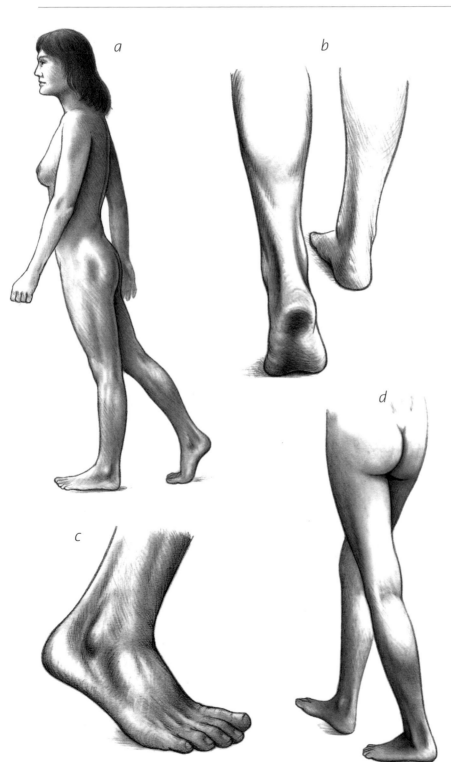

These are just a few of the many movements involved in the action of walking.

a
This side view demonstrates the curve of the spine and the muscles of the left leg, helped by the use of reflected light.

b
The position of the feet in this closeup are the same as shown in *a*, but reversed. Observe the forms of the Achilles tendon, gastrocnemius, and soleus muscles.

c
Compare the appearance of this foot to the one on page 140.

d
This pose is helped by drawing a stronger line down the front of the left leg and softly indicating the other leg to give the picture added depth.

The figure

Drawing the running figure

You are unlikely to have an opportunity to draw figures running, and if you did, then only lightning sketches would be possible.

a
The position of the figure before sprinting. The muscles are tensed, ready to propel the body forward.

b
This is a similar view to 155b but with more detail at the back of the leg.

c
A feeling of action is helped by the angles of the arms and strong light and shade.

d
Male figure running with the right leg being the most obvious feature, as it pushes the body forward.

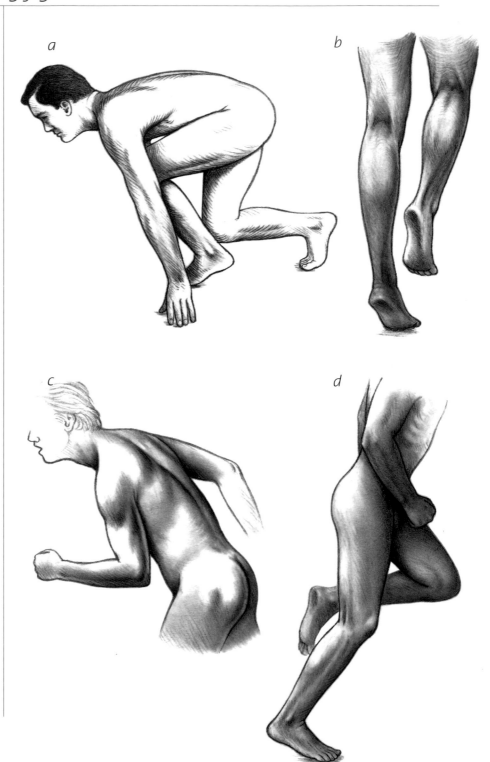

Jumping figure

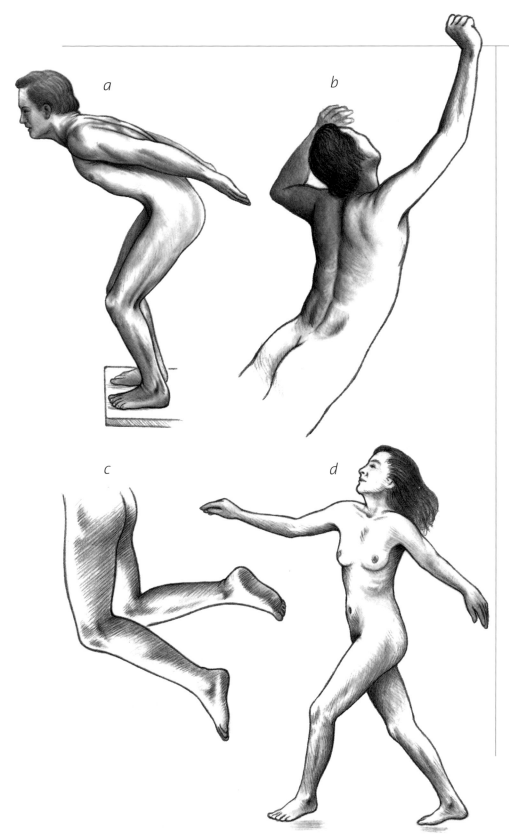

Drawing action lines through the figures and using only a few strokes will help to get the essential movements. This is often how cartoonists start to draw, reducing their characters to a few basic lines.

a
The body tensed before diving. The form of the biceps femoris muscle in the arm and the tendons flexing in the knee can be seen.

b
A leaping figure with emphasis on the muscles of the back. Visualize an action line from the neck to the buttocks and another joining it coming down the right arm.

c
This is a simpler, linear drawing but with two views of the feet.

d
The pose that might be adopted when about to jump. Again, visualize an action line running from the head down the right leg to the foot, and try to visualize the position of the rib cage in relation to the pelvis.

A

abdominal muscles 74
antagonistic muscles 19
arms 80–113
 bones 84–5, 92–3, 94–5
 drawing 88–9
 humerus 73, 92–3, 94
 movement 149
 muscles 19, 86–7, 92–4, 100–1
 radius 92, 96–7,
 ulna 92, 96, 98–9
 wrist 102–3

B

back 58, 59, 62, 63, 64–5
biceps muscle 19
body types 20–1
bones
 see also skeleton
 arm 84–5
 coccyx 56, 119–21
 elbow joint 95
 feet 126
 forearm 96–9
 hand 102, 104–5
 humerus 73, 92–3, 94
 knee 132–3
 legs 118, 122–5, 128–9
 lower extremity 116–29
 mandible 36
 nose 30
 pelvis 118–21
 radius 92, 96–7
 rib cage 52, 60, 61
 scapula 66, 70–1, 73, 84–5, 90–1
 shoulder 66
 skull 26–7
 spine 54–8, 61, 62, 119–21
 tissue 8
 trunk 50, 51
 ulna 92, 96, 98–9
 wrist 102

C

calf muscles 134
carpal bones 102, 104–5
cervical vertebrae 57

chin 36–9
coccyx 56, 119–21
contours 13

D

detailed facial drawings 44–5
dividing up the figure 152
drawing
 see also tips for drawing
 abdomen 75
 arm 88–9, 112–13
 equipment 10
 feet at rest 138–9
 feet in flexion 140–1
 female torso 79
 hands 108–11
 legs 142–3
 male torso 76–7
 movement 144–57
 neck 41
 techniques 9, 11
 torso 113

E

ear 34, 35
ectomorphs 20, 21
elbow joint 95
endomorphs 20
equipment 10
eyes 28, 29

F

face 26–7, 42–3, 44–5
feet
 bones 126
 drawing at rest 117, 138–9
 drawing in flexion 140–1
 ligaments 127
 muscles 136–7
female pelvis 121
female torso 48, 79
femur 122, 128–9, 132–3
fibula 117, 124
figure drawing 152–7
fingers 104–7
forearm 96–9, 110–11

H

hands 104–11
head and neck
 ears 34–5
 eyes 28–9
 jaw 36–9
 mouth 32–3
 neck 40–1, 148
 nose 30–1
 skull 26–7
 tips for drawing 25, 42–5
hips 150
 see also pelvis
humerus 18, 19, 73, 92–4

J

jaw 36–9
jumping figure 157

K

knee 116, 125, 128–9, 132–3

L

legs
 bones 118, 122–5, 128–9
 drawing 142–3
 movement 151
 muscles 116, 132–3, 134–5
ligaments 103, 117, 127, 129, 136–7
light direction 13
lines 12, 13
lower arm 96–9, 100–1
lower extremity 114–43
 bones 116–29
 drawing 117, 138–43
 muscles 130–7
lower leg 134–5
lumbar vertebrae 62, 119

M

male pelvis 120
male torso 48, 49, 76–7
mandible 36–9
measurements 42–3, 152
mesomorphs 21

mouth 32, 33, 38, 39
movement 38, 110–11, 144–57
muscles
 abdomen 74
 agonistic action 18
 antagonistic action 19
 arm 19, 86–7, 92–4, 100–1
 back 58–9, 63
 ear 34
 eye 28
 face 26–7
 feet 136–7
 fingers 106–7
 hand 106–7
 knee 132–3
 leg 116, 132–3, 134–5
 main muscles 16
 mandible 36
 mouth 32
 neck 40
 overview 16
 pectoral 72
 shoulder 18, 70–1, 73
 thigh 130–1
 tissue 9
 types 17

N

neck 40–1, 148
 see also head and neck
noses 30–1

O

organs of body 48

P

papers for drawing 11
patella 125, 128, 132
pectoral muscles 72
pelvis 118–21
planes 13
proportions 42–3, 152

R
radius 92, 96–7
ribs 52, 53, 60–1, 70
running figure 156

S
sacrum 56, 118–21
scapula 66, 70–1, 73, 84–5, 90–1
seated figure 154
shoulder
 blade 66, 70–1, 73, 84–5, 90–1
 drawing 68–9
 girdle 70–1
 muscles 18, 70–1, 73
skeleton
 see also bones
 back 62
 complete 14–15
 muscles 16
 rib cage/sternum 52
 trunk 50, 51
sketching 12–13
skull 26–7
 see also head and neck
spine 54–8, 61–2, 119–21
standing figure 153
sternum 52

T
tactile lines 12, 13
tarsus 126
techniques 9, 11
 see also tips for drawing
thigh muscles 130–1
thorax 60–1
tibia 117, 123, 128–9, 132–3
tips for drawing
 see also drawing
 head and neck 9, 25
 lower extremity 17
 movement 147
 trunk 49
 upper extremity 83
torso 76–9, 113
trunk 46–79

U
ulna 92, 96, 98–9
unvaried lines 12
upper arm 92–5
upper back 58
upper body movement 148
upper extremity 80–113
 bones 84–5, 90–9, 102–5
 drawing 83, 88–9, 108–13
 muscles 86–7, 92–3, 100–1, 106–7

V
vertebrae 57–8, 61, 62, 119

W
walking figure 155
wrist 102–3